University of California Press **Berkeley Los Angeles London** Published in association
with the Graduate School of Journalism, Center for Photography, University of California, Berkeley

WAYNE F. MILLER

chicago's SOUTH SIDE 1946-1948

Foreword by Orville Schell | Commentaries by Gordon Parks and Robert B. Stepto

**TO THE JOHN SIMON GUGGENHEIM
MEMORIAL FOUNDATION**

University of California Press
Berkeley and Los Angeles, California

University of California Press, Ltd.
London, England

© 2000 by the Regents of the University of California
All photographs © by Wayne F. Miller
Gordon Parks's essay © 2000 by Gordon Parks
Robert B. Stepto's essay © 2000 by Robert B. Stepto
Wayne F. Miller's essay © 2000 by Wayne F. Miller

Design and composition: Nola Burger. Text type: Scala. Display
type: Franklin Gothic Book and Demi. Printing and binding: Asia
Pacific Offset, Inc.

Library of Congress Cataloging-in-Publication Data

Miller, Wayne F.
 Chicago's South Side, 1946–1948 / Wayne F. Miller ; with a
foreword by Orville Schell and commentaries by Gordon Parks
and Robert B. Stepto.
 p. cm. — (George Gund Foundation imprint in African American
studies) (Series in contemporary photography ; 1)
 ISBN 0-520-22316-0 (alk. paper)
 1. Afro-Americans—Illinois—Chicago—History—20th century—
Pictorial works. 2. Afro-Americans—Illinois—Chicago—History—
20th century. 3. South Chicago (Chicago, Ill.)—History—20th
century—Pictorial works. 4. South Chicago (Chicago, Ill.)—His-
tory—20th century. 5. Chicago (Ill.)—History—1875- —Pictorial
works. 6. Chicago (Ill.)—History—1875- I. Title. II. Series. III.
Series: Series in contemporary photography ; 1

F548.9.N4 M55 2000
977.3'1100496073—dc21

 00-022186

Printed in Hong Kong

09 08 07 06 05 04 03 02 01 00
10 9 8 7 6 5 4 3 2 1

The paper used in this publication meets the minimum require-
ments of ANSI/NISO Z39.48-1992 (R 1997) (Permanence of
Paper).

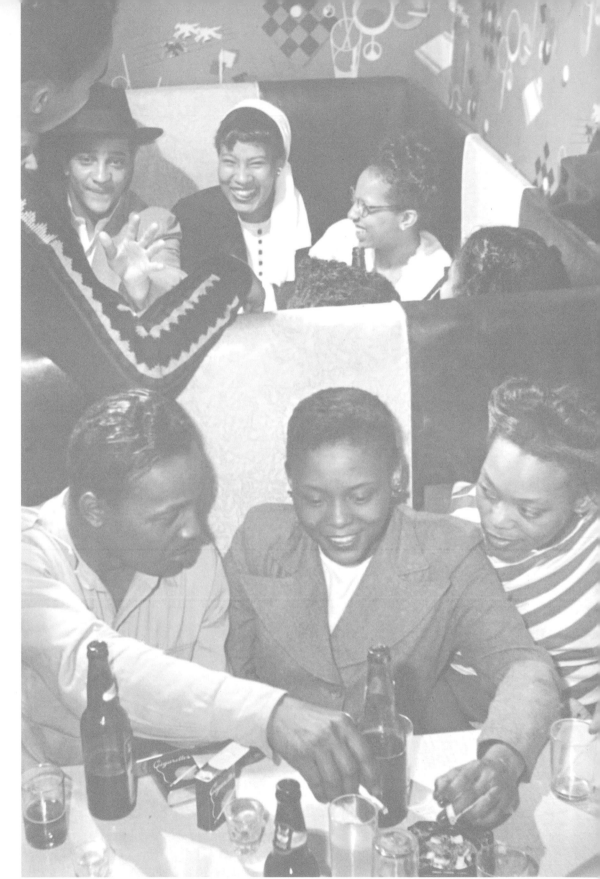

SERIES IN CONTEMPORARY PHOTOGRAPHY

CENTER FOR PHOTOGRAPHY
GRADUATE SCHOOL OF JOURNALISM
University of California, Berkeley

Ken Light, Editor

1. Wayne F. Miller, *Chicago's South Side, 1946–1948,*
with a foreword by Orville Schell and commentaries
by Gordon Parks and Robert B. Stepto

ORVILLE SCHELL

Lovers of photography who frequent gallery exhibits usually have only a few fleeting moments to "look at" the works of a given photographer. The experience of walking through an exhibit ends up being not too different

from watching a movie—where images appear and vanish in rapid sequence. The wonderful thing about working in a photo gallery—in my case a gallery opened in 1996 at the Graduate School of Journalism at the University of California, Berkeley, with a generous grant from the Susie Tompkins Buell Foundation—is that it enables me and other faculty and staff members to walk past a show scores of times every day so that each individual image becomes almost as engraved in the mind's eye as the visage of a colleague or friend one regularly meets. Such familiarity, or perhaps it would be more accurate to call it a form of individual "possession" of a series of photographs, ultimately makes it evident if a photographer's work has a true depth or greatness. The great photographs grow on you much as a piece of music grows more interesting and satisfying with each listening.

Having lived with Wayne Miller's extraordinary photos of Chicago in the late '40s for several months,

so that I could steep in their images, was something like introducing them into a slow process of distillation. What was left, now happily reincarnated in this book, was an essence of jolting power and purity.

As in most great photography, the viewer feels no hint of Miller's intruding presence, an extraordinary feat given the fact that he was a young white man navigating his way through a black world. What Miller has produced is a remarkable document of a moment in time—the kind of show that transcended even what I was able to imagine in the most ideal form.

This type of leisurely unobtrusive photography is increasingly hard to find in the fast-paced, corporatized, celebrity-based world of photojournalism. It is our hope that by exhibiting work such as Miller's, which was displayed in our gallery in early 1998, we will be able to inspire a new generation of photographers with just his sensibility.

GORDON PARKS

I was born a black boy inside a black world. So, like moments rising out of my unfathomed past, many of Wayne Miller's images slice through me like a razor. And I'm left remembering hunks of my time being murdered away as I suffered blistering hot summers or ate the salt of equally cruel winters. For me those crowded kitchenettes, the loneliness of rented bedrooms, and the praying in leftover churches remain an ongoing memory. Here, far from the Kansas prairies where I was spawned, I just couldn't melt into the ghetto's tortuous ways—unlike so many others who, after a hard day's work, numbed the misery with booze and soothing music. "Hello blues. Blues, how do you do?"

New York's Harlem, Chicago's South Side—both cities of blackness crammed inside larger cities of whiteness—offered mostly hunger, frustration, and anger to their tenement dwellers. And those same tenements that imprisoned thousands are still there, refusing to crumble. I recall swarms of slow-moving people passing the chili shacks, rib joints, storefront churches, and funeral parlors—all with the same skin coloring but rarely speaking to one another. When you left your door you walked among strangers. Now there are a few new buildings going up to look smugly down at the old ones. Good music, laughter, and prayers are still in the air, but for many young blacks music, laughter, and prayers offer at most an uneasy peace.

At times I became disgruntled with this social imprisonment, even became angry with myself for not finding a way out. But eventually that anger grew tired of hanging out with me day and night, and little by little it left me alone. And for a long time I remained alone—still desperately searching for bread in the rubbish. That search was awful. I was constantly reaching for something denied me, or perhaps longing for something lost along the way.

Slowly the shadow of hope had spread its presence. Anger had fled—running as though it were escaping the violence festering inside me. Then gradually the light that avoided so many other hearts began falling on mine. But be free of doubt. Wayne Miller shows us what I remember most—those garbaged alleys and wintry streets where snowflakes fell like tears, those numberless wooden firetraps called home, the homeless gathered around flaming trash cans to escape the hawk of winter, those crudely worded signs — COAL 50 cents, WOOD 25 cents — those old men reclining in forgotten chairs left at curbside for moving vans that never showed up. There where funerals had become a habit and hardship never seemed to be out of order.

How feeble the uncertainty! Wayne's camera appears to be inexhaustible as it goes from life to life—abruptly leaving one door to arrive at another. Then somewhere, perhaps a short distance away in a

pool hall or restaurant, he finds brothers and sisters of the soul muddling through the grime and sipping Fox Head beer. Yet to some of their fortunate kinfolk that was a small thing. Having swum through the dust, they were now in tuxedos and ball gowns, dancing to the strains of Ellington's uptown music in a softly lit ballroom. "Hug me, sugar, and let the good times roll."

Where, one might ask, does Wayne Miller fit into this chaos that plagued my youth? A good question. Did he possess an insatiable curiosity that had to be fed, or was he perhaps treading the path of any competent photographic journalist? A close acquaintance with him for many years gives shape to my own answer. He was simply speaking for people who found it hard to speak for themselves. And that trait takes full measure of any journalist who is worth his salt. Once when a reporter wrapped that question around his neck, he answered unhesitatingly, and rather bluntly, "I am interested in expressing my subjects. I won't turn a nice guy into a son-of-a-bitch or a son-of-a-bitch into a nice guy. There are people who make pictures and people who take them. I take them. At times I have been so busy capturing what I was seeing that it was impossible to cry and work at the same time. Good images emerge from good dreaming. And, to me, dreaming is so important."

Wayne went to wherever his conscience called him, and his camera's eye baptized whatever confronted him. Earthbound and free of any shadowy miscellany, he made contact with the roots. And as no one can stop the waters flowing, neither can one eliminate his powerful images from our past. They will still be here with us, even if those tenements crumble in time, exhausted.

ROBERT B. STEPTO

Wayne Miller's photographs capture a black Chicago of fifty years ago: the South Side community that burgeoned as thousands of African Americans, almost exclusively from the south migrated to the city during the

Great Migration of the World War II years. Of course, a South Side black community already existed, but in the 1940s migrants were the ones who pushed the borders of the earlier "Black Belt" south and east, so that the neighborhoods depicted in these images no longer represented the periphery of the black South Side, but the center of it. And the crossroads of the center was the intersection of 47th Street and South Parkway (now, Martin Luther King, Jr., Drive), which fittingly is offered as one of the first images of this remarkable collection.

Thus we begin at the crossroads of Bronzeville, as the "Black Belt" was renamed in the 1940s, the power base of the first truly powerful black Democratic congressman, William Dawson, though we are reminded of that in these images only by an election poster, which appears not as a political statement or historical marker but more as a part of the urban tapestry attracting the photographer's eye. That is typical of how Wayne Miller works in this sequence of images: he doesn't let "headline history" take over; this is news from the street presented in most of its variety.

Much is on view that is of interest to the student of mid-century black Chicago. These are the neighborhoods Richard Wright's Bigger Thomas traversed in

Native Son, whether trudging to work, sauntering to the Regal Theater, or fleeing the police. This is the Bronzeville limned in Gwendolyn Brooks's earliest poems, where we meet Sadie, Maud, and Satin-Legs Smith and follow them into yards and alleyways, and up flights of stairs to cramped "kitchenette" apartments. The kitchenette apartments in Miller's photographs, bursting with people of all ages, sleeping, dressing, courting, dreaming "the dream deferred," suggest the set for Lorraine Hansberry's acclaimed play *A Raisin in the Sun.* The images of street life portray what inspired the urbanscapes of the painter Archibald Motley, and they give life to what is often dryly offered in pioneering sociological studies such as Horace Cayton and St. Clair Drake's *Black Metropolis.*

A few celebrities appear in these images — Paul Robeson, Ella Fitzgerald, Duke Ellington. But mostly we see ordinary folk, "the people," and we see lots of them, in clubs and at church, but also at sporting events and at parades. In this way, the photographs remind us that the migration to Chicago "packed in" blackfolk in ways some studies don't account for: what a wonder it was to go to Comiskey Park and see the Negro League ballteams play; how amazing it must have been to crowd the curbs of South Parkway on the day of Bronzeville's annual Bud Billiken

Parade and see black civic leaders, black marching bands, and black pinups beaming from the backseats of brand-new convertibles.

Bronzeville offered a civic life, and that was something many migrants were searching for. Yet their aspirations were also more personal and familial. Miller's keen sense of this is evident in his memorable portraits of parents with children; even when the figures are not looking at each other, one senses the intimacy, the myriad paths of caring and nurturing. Special to these photographs is the inclusion of portraits of fathers with their children: these counter at least some of the pronouncements about the absentee black father and the demise of the black family in the urban north.

Equally unique to this collection is the occasional image of a black man reading. In one image, a kitchenette scene, a man reads on in his comic book despite the chaos surrounding him; in another, a small youth on a stoop pours through a magazine as big as she is. Maybe the youth is reading comics too, but that is not the point. The point is these images give these figures intelligence, curiosity, and possibly an inner life. They are powerful reminders of how largely unavailable literacy was back where the migrants came from, and thus they remind us of how for so many education was a goal in the north.

Of course, work, good-paying work, was the key lure for thousands of migrants, and at mid-century Chicago was at the height of its industrial order. The stockyards were still open, the steel mills were booming, and small manufacturers were still in the city, not the suburbs. One would thus expect Wayne Miller to photograph the countless scenes of black migrants toiling in the industrial labor force, much as Edwin Rosskam did a decade before. He does so, but with more of an eye to capturing a sense of the migrant in transition from one world to another. Consider, for example, the images of black men in horse-drawn wagons, rumbling down urban streets. On the one hand, these images record the fact that some migrants worked not in the industries but in the alleyways, selling ice and vegetables and peddling whatever they could from the backs of wagons. On the other, these images forcefully say some other things as well: some migrants clung to the world they knew, and some migrants were forced to cling to what world they knew. Whatever the case, few images say more about the confusions and contradictions of black migration to the industrial north than those Miller photographs of black Chicago men rattling along in horse-drawn wagons, slapping the reins as if they were still in Alabama.

After viewing the whole of this collection, one is struck by how many of the images are of winter scenes. Is this simply a matter of when Miller and his camera were in Chicago, or is a large, commanding theme being deliberately mounted? Certainly, one huge shock for every black migrant was the weather: each blast of Chicago winter probably spawned ten new blues tunes, and Miller's photographs suggest something of that. But the images capture something else as well. I think here of the image of a child's sled, with three bushels of coal balanced upon its bed. Several readings are possible, but I choose to reach back to my memory of how the children of migrants hustled as much as their parents did, queuing at markets to cart groceries in toy wagons in good weather, only to do the same with their sleds in the winter. Don't see that sled carting coal and think of a deprived childhood; think instead of a black child on the move and on the make, hustling to defy the odds in Chicago, the city of muscle and big shoulders.

WAYNE F. MILLER

The story of these photographs begins half a world away—in the South Pacific, aboard a U.S. aircraft carrier. As a World War II combat photographer, I'd seen an incredible waste of lives and resources. Just after the first

atomic bomb was exploded, I witnessed and recorded the horror of Hiroshima, the ultimate denial of sanity.

One evening toward the end of the war I drifted out on deck and joined a group of my shipmates. We swapped jokes and gossip for a while, but then our mood shifted, and we began to discuss the blind futility of war. Many of us felt we were fighting in the dark, by instinct, against enemies we didn't know and who didn't know us. Guns and bombs might win the war, but ignorance and suspicion would surely lose the peace. Only through awareness and understanding, we agreed, could foes ever become friends and friends become neighbors.

I never forgot that conversation. It convinced me that after the war, with a camera, I might be able to document the things that make this human race of ours a family. We may differ in race, color, language, wealth, and politics. But look at what we all have in common—dreams, laughter, tears, pride, the comfort of home, the hunger for love. If I could photograph these universal truths, I thought that might help us better understand the strangers on the other side of the world—and on the other side of town.

So I began to search for a project that would embody these universal truths. And not long before the war ended, I received a grant from the Guggenheim Foundation to photograph "The Way of Life of the Northern Negro." This was a defined group, and a large population lived in Chicago, my hometown.

Getting started was my biggest problem. Where was I to go? How was I to get there? Who was I to see? What was I to say? After two months of stewing and stalling, I finally slung a camera around my neck and went out there to meet the people of South Chicago.

I had good luck almost from the start. Guided by some angel, one of my early stops was at the Parkway Community House. It was a gold mine. Horace Cayton, the director, coauthor with St. Clair Drake of the sociological study *Black Metropolis,* knew everyone and, without question, was most generous in sharing his immense knowledge and contacts with me. Interracial groups of artists, activists, social service personnel, and society leaders with diverse interests often gathered at the community house for conferences and social occasions. It was always exciting. On one of these occasions, I photographed a young

white woman guest engaged in hanging a framed picture. She was hammering a nail into the wall with the butt of a revolver.

An office at the rear of the community house was occupied by a struggling new magazine called *Ebony*. Here another angel intervened. Horace introduced me to its editor, Ben Burns, who promptly gave me photographic assignments. Ben assigned me to stories I could never have discovered on my own. I saw and photographed things that would otherwise have remained invisible or inaccessible.

Only a few times, while working on my Guggenheim grant, was I challenged by curious South Siders. "What you doin' with that camera around here?" they'd say. So I'd cheat a little and answer, "Oh, I'm with *Ebony* magazine."

As a rule, though, those black men and women of Chicago were gracious and generous. Conversation was easy, doors were opened, invitations were offered. If questioned about my camera, I simply said that I wanted to take pictures of people. No further explanation was necessary.

And when I spotted an interesting scene or situation, I didn't try to hide myself or my camera. That would only have aroused resentment and mistrust. Instead, I often approached the people involved. "Please," I said, "pay no attention to me. Just keep doing what you're already doing." Believe it or not, they usually did.

Why? I can think of only one reason. Somehow or other, they understood that my motives were sympathetic and uncritical. They sensed I wasn't looking for good or for evil. My search was for the everyday realities of life — *their* view of the world, *their* feelings, *their* attitudes, *their* stories. This made a big difference, I think. In any case, I was given the greatest compliment a documentary photographer can receive: I was accepted and left alone to do my work.

I walked the streets and alleys of the South Side day and night. Some mornings, on certain blocks, it had the feel and flavor of a small town. Men and women were on their way to work, sidewalks were swept, grocery stores opened, kids packed off to school. Later, toddlers played on doorsteps, women gathered to gossip, carts and wagons began to jostle through the streets. Then the bars and pool halls were unlocked, and almost every street corner was decorated with a few idle figures, just hanging out.

Looking back, I find that I gravitated to places where people were having fun, raising hell, trying to raise money, making trouble, and getting ready to make love. Once I even photographed a veteran prostitute on the job with one of her regulars. They didn't mind. Afterward, when asked if I had gotten the pictures I wanted, I said that it had happened a bit fast; he then invited me to come back next Tuesday, when he would arrange for me to have all the time I needed.

One of my favorite haunts, a bar on 45th Street, had a lurid reputation. Its clientele was stockyard workers, day laborers, and a few unattached women. Some passersby might step off the sidewalk and into the street rather than stroll by its open doorway. But once inside, I couldn't see why anyone would be so concerned. True, the crowd was a bit noisy, relaxed, and uninhibited. Though I never saw another white face on the premises, I always felt comfortable, the way one feels among friends. Whenever I dropped in to make photographs or for a beer, I was welcomed and left alone.

On Friday and Saturday nights, the crowd, the tempo, and the noise escalated. The management had a bouncer at the front door and one at the back. Invariably someone would get extra noisy or pick a fight and then the bouncers would converge and catch the violator between them, and after he had slid to the floor, out the door he would go. It was so

crowded one night that I couldn't find a way to take photographs because my camera was designed to make pictures from a waist-level viewpoint. So I climbed up onto one of the cocktail tables. The people using it didn't seem to mind. After a few minutes, I felt someone tugging at my trouser leg. I looked down into the face of a man with obvious displeasure in his eyes. He said, "Get down, boy, you don't belong here." He led me over to his two friends standing along the side wall. This was the first time I had ever been confronted, and I was wondering what would happen next. At that moment the two bouncers appeared and said, "Leave this man alone—he's all right." My relief was akin to learning that I had just been elected to a high office.

A few months later, that same bar let me know that I was all right in another way. Every summer the owners and the bartenders threw a big picnic for their friends and favored customers. I was invited too—a gesture I'll never forget. Two huge dump trucks were hired, cushioned with straw, loaded with food and beer and guests, and then driven to the Forest Preserve, a park on the outskirts of the city. We ate. We drank. We danced. We flirted. A few of us picked fights. But everybody seemed to have a fine time. I was happy as well, because I returned to Chicago with a sense of well-being and some good photographs.

I also took many hundreds of photographs, in fact and in memory, wherever I happened to wander.

Of a policy parlor in a dead-end alley, where cleaning ladies and night watchmen came to bet the rent money—and almost always lost.

Of Silvester Washington—a Chicago Juvenile Police Officer nicknamed "Two Gun Pete" like the maverick General George Patton, he sported a pair of pearl-handled revolvers. On his own he created and presided over a kangaroo court, which met with juvenile offenders every Saturday in the locker room of his Wabash Avenue police station.

Of young women being trained by undertakers to prepare corpses for the last rites and final viewing. They, the students, wore vivid lipstick, precarious high heels, and fashionable dresses; they giggled and twittered while they worked. It seemed more like a beauty salon than a funeral home.

Of the emergency room at the Provident Hospital. And of a man, throat sliced open from his right ear to under his chin, whose wound was closed by a doctor without surgical gloves. And of a woman who'd swallowed Lysol, hoping to kill herself. And of a kid, six years old, who'd somehow managed to embed popcorn in his ear.

There were also thousands of photographs I didn't take. Some of those opportunities I didn't even perceive. My eyes and instincts weren't good enough. When I think of what I missed, it makes me want to cry. But I'm consoled by the knowledge that the whole picture can't be contained in the files of any one photographer. The subject is too vast, too complex, too diverse, and too mysterious.

So this book, like my files, is incomplete. It only suggests the essence of what I set out to document. That I had the arrogance to even attempt such a grand concept, now makes me uncomfortable. But I did the best I could with the tools I had, and the photographs you see on these pages are the result. If in any way they help you to better understand "The Way of Life of the Northern Negro"—or, for that matter, your own—a bit of the mission that began on the deck of an aircraft carrier in the South Pacific will have been accomplished.

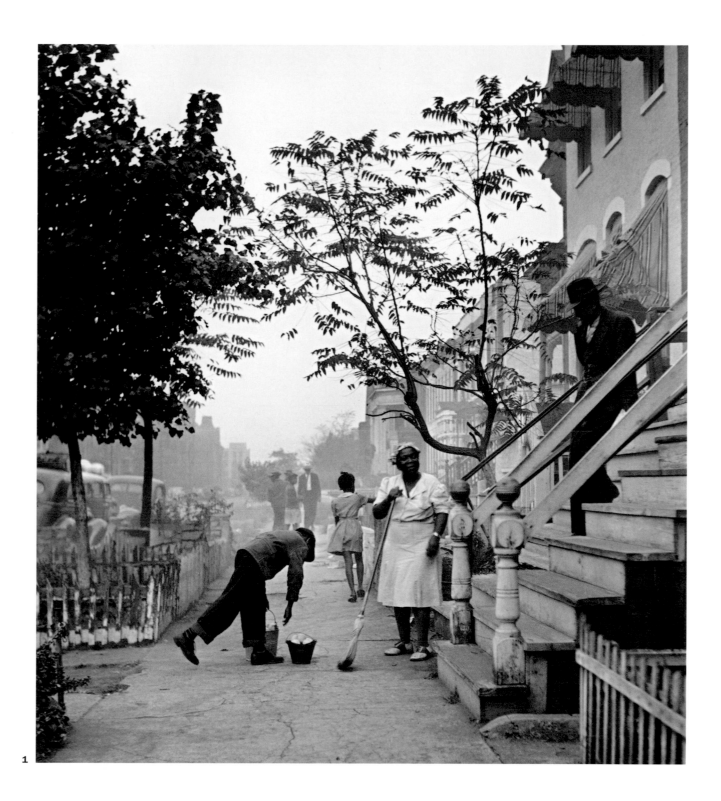

1

Sweeping the sidewalk in the morning.
The boy is delivering groceries.

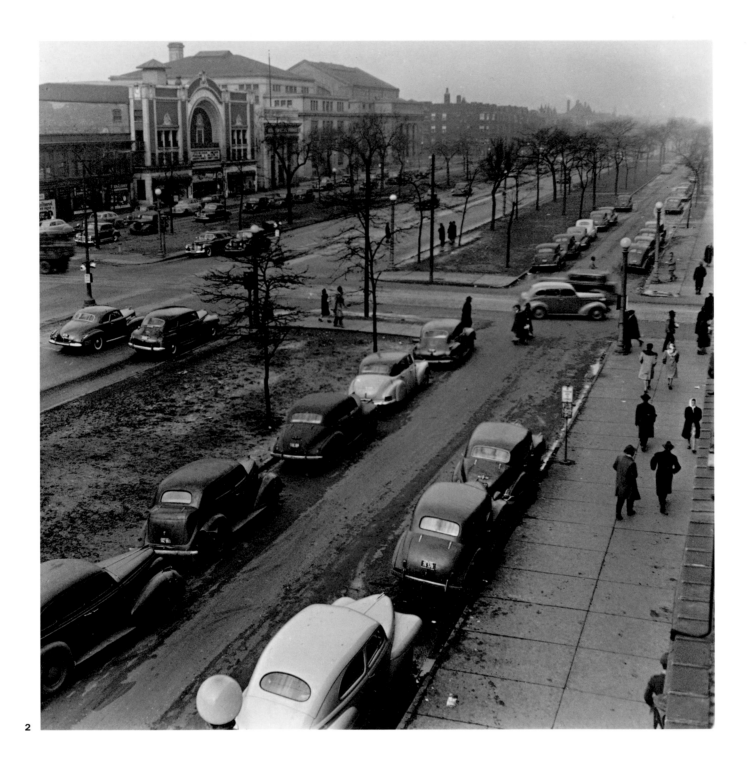

2

Looking north on South Parkway
to 47th Street, crossroads
of the South Side

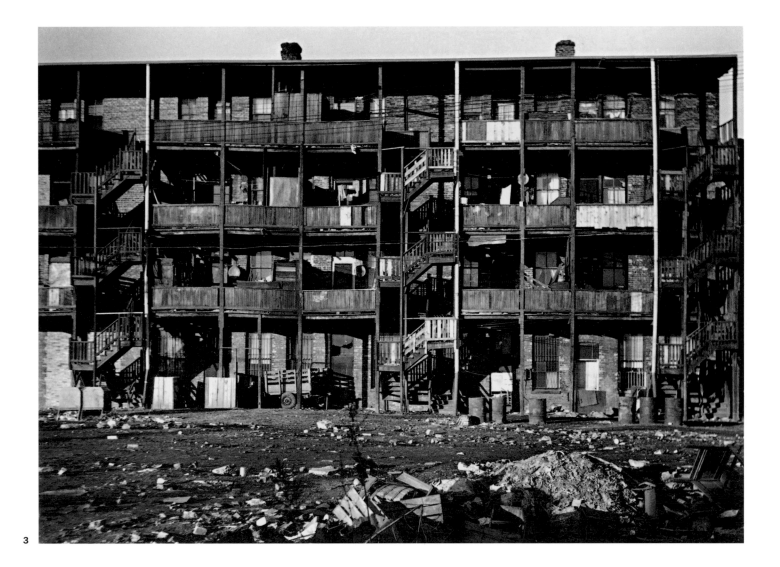

3

A tenement on South Indiana Avenue, the type of housing for half of the city's black children

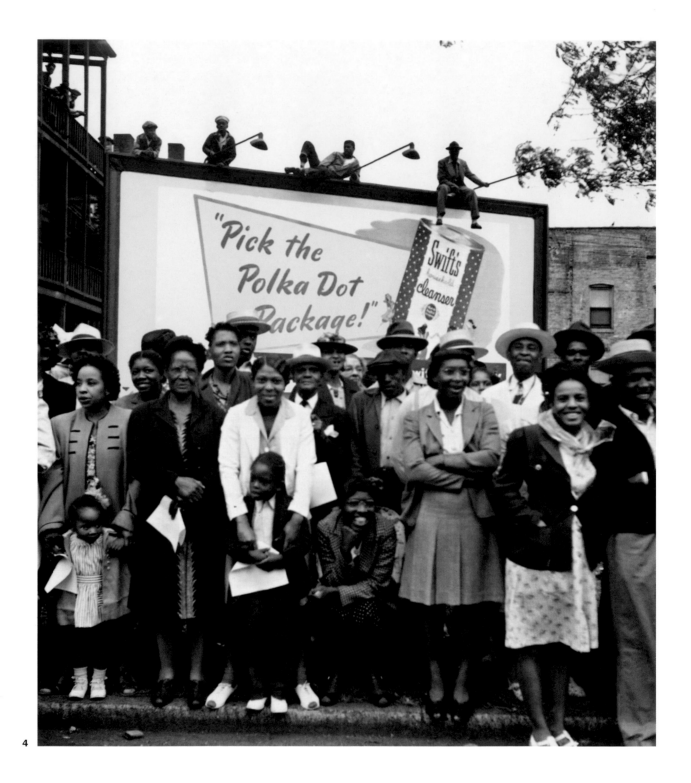

4

Spectators at the Bud Billiken Parade

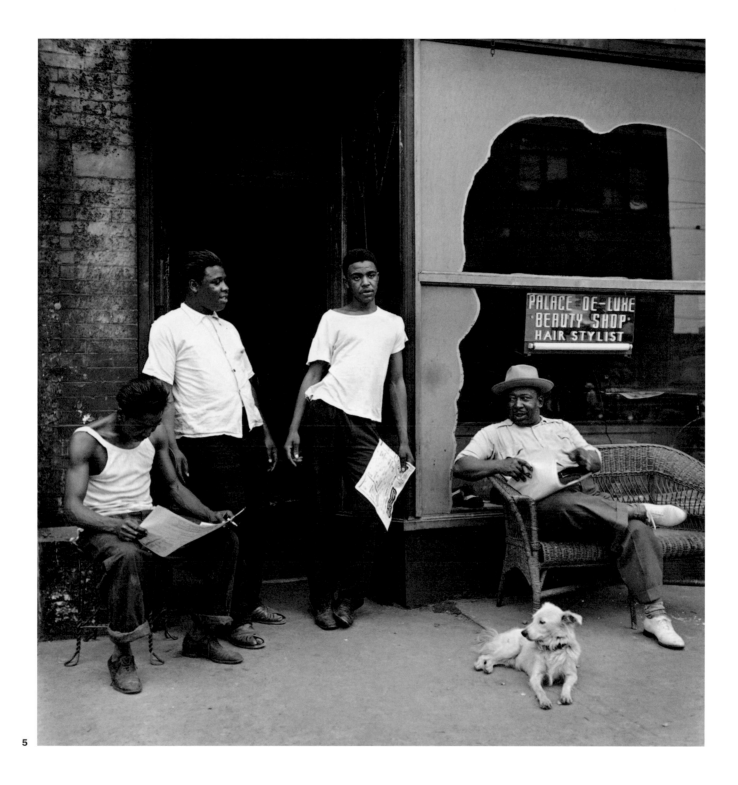

Four men on sidewalk outside beauty shop

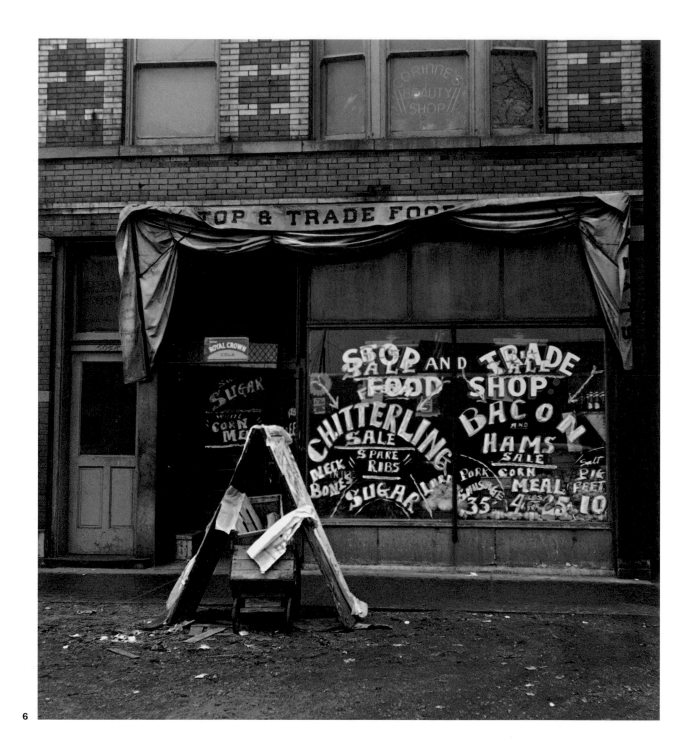

6

Storefront

7

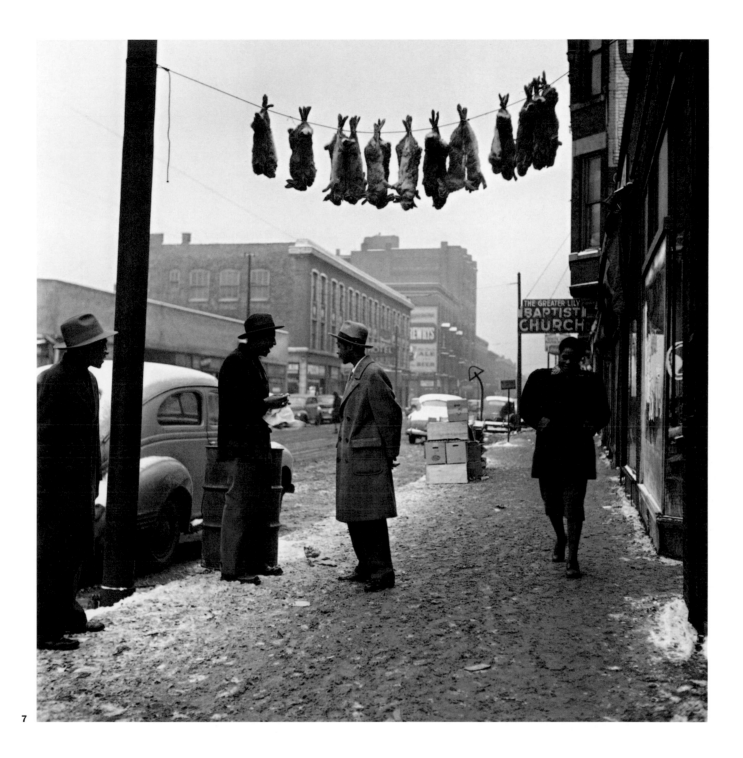

Rabbits for sale, 1948

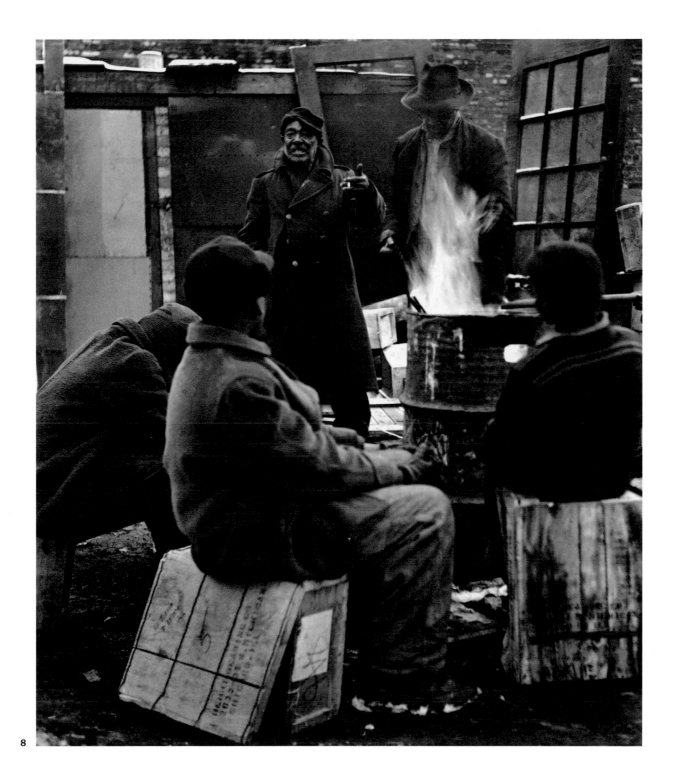

Storyteller

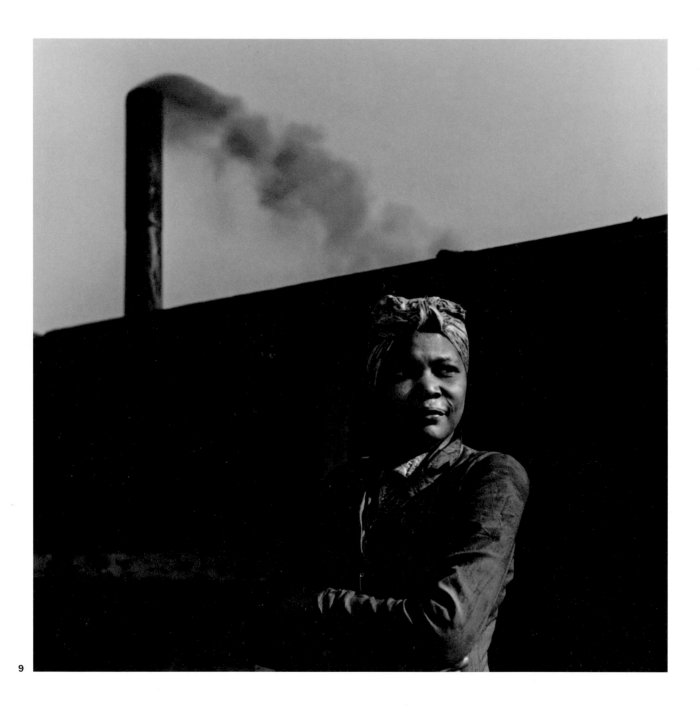

9

A woman and her squatter's shack on a cold winter day, 1948. It was built of cardboard and plywood on Lake Michigan's beach.

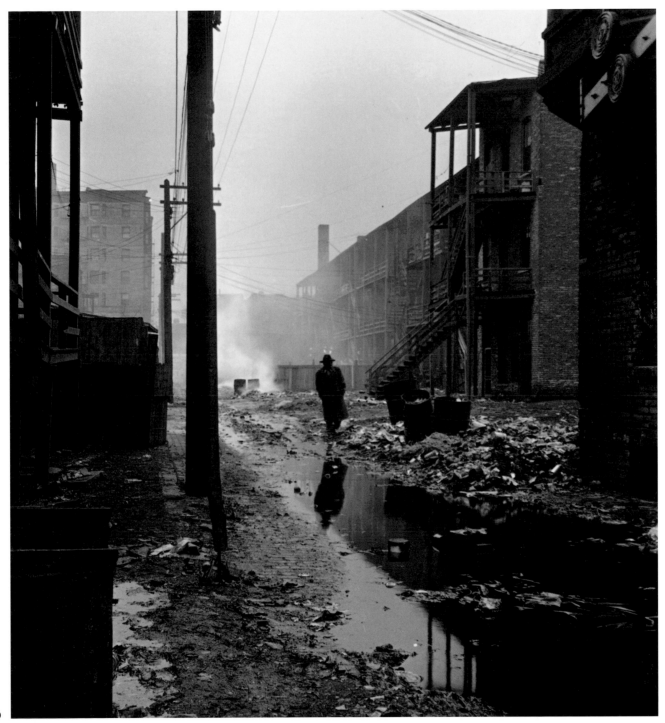

10

An alley between overcrowded tenements, with
garbage thrown over the railings of the back
porches. Most of the area's tenants were transient.

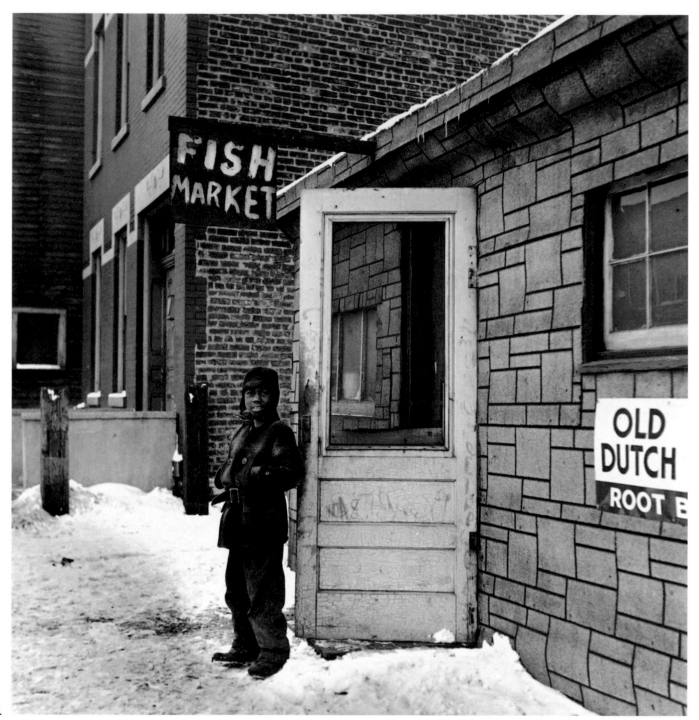

11

Boy outside "Fish Market"

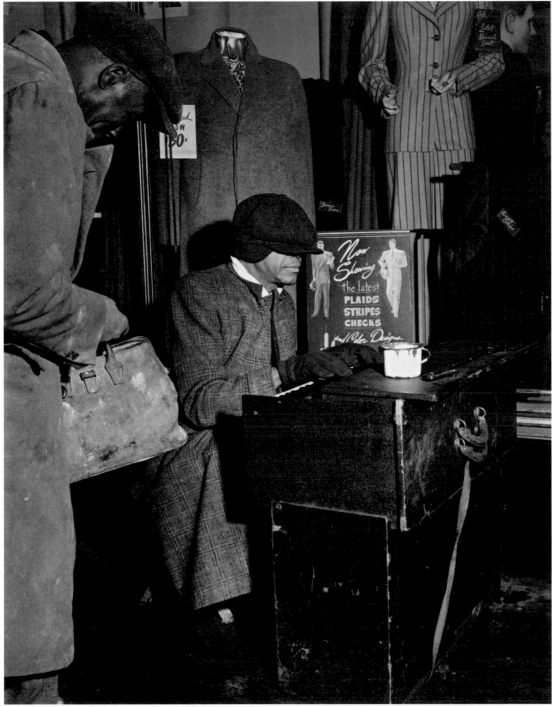

Blind man with street piano

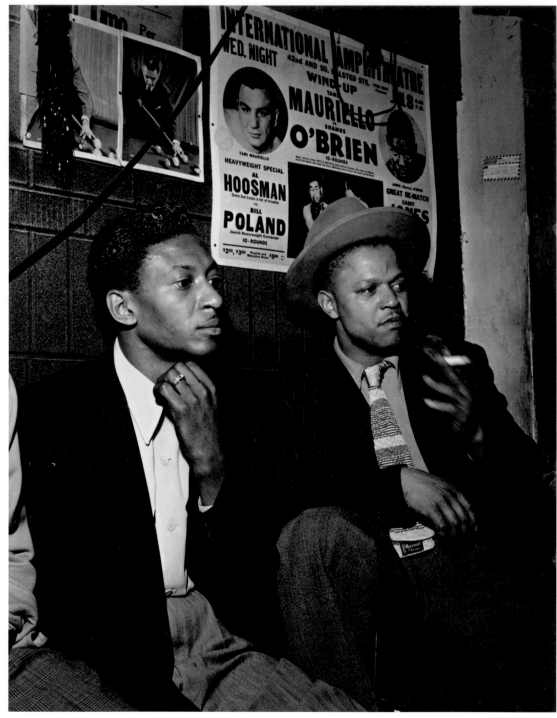

13

Spectators at pool hall

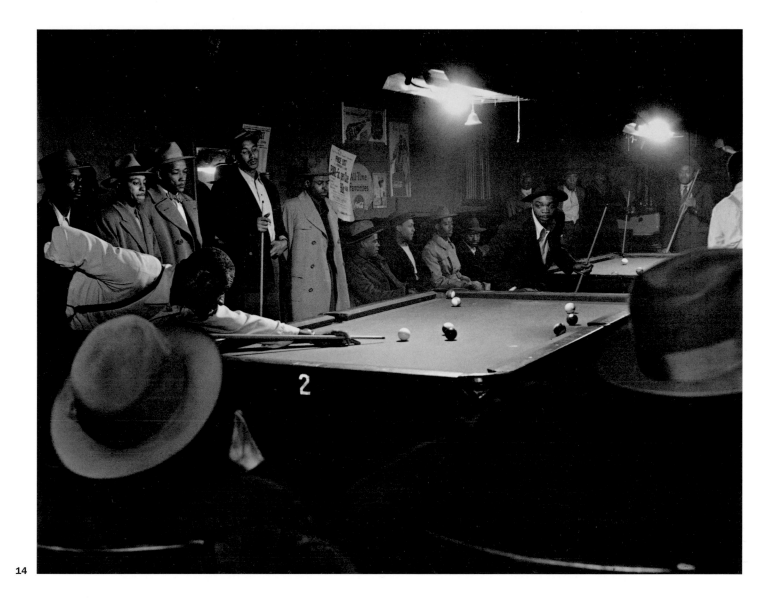

14

Afternoon game at Table 2

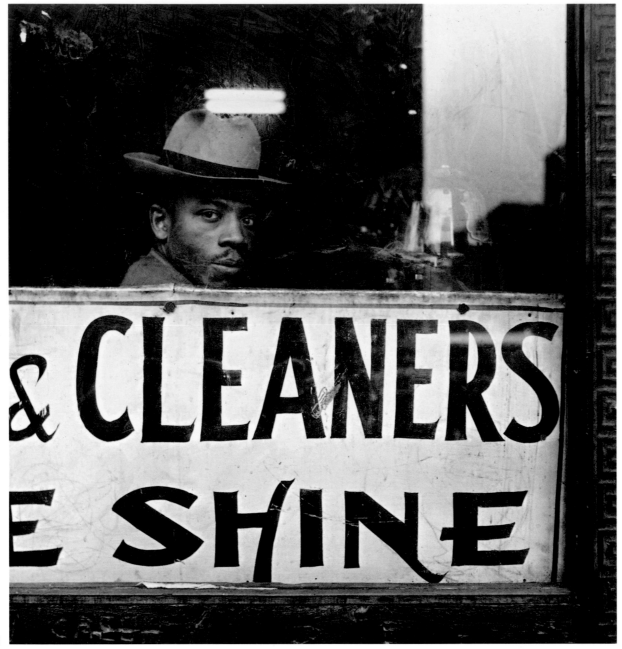

15

"Simple" was a character that poet Langston Hughes used in his newspaper column. Upon seeing the man in this photograph, Hughes said, "That's him."

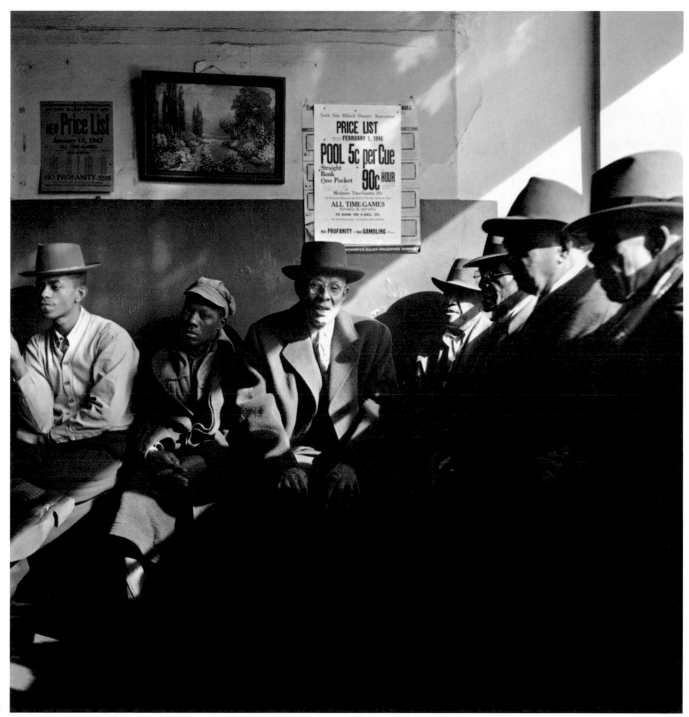

Keeping warm, pool hall

17

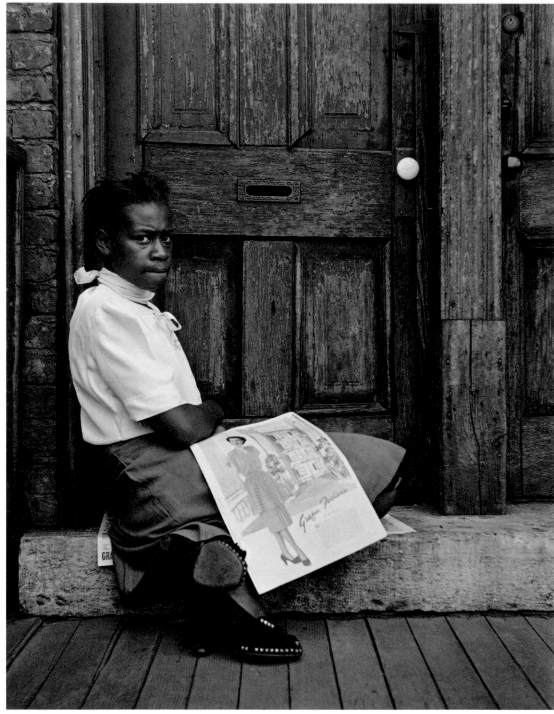

Girl with newspaper fashion supplement

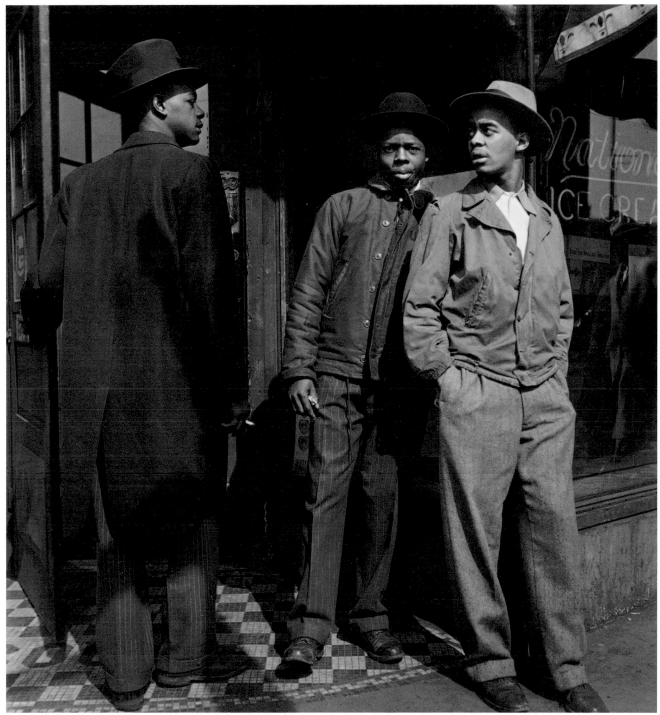

Three young men standing in doorway

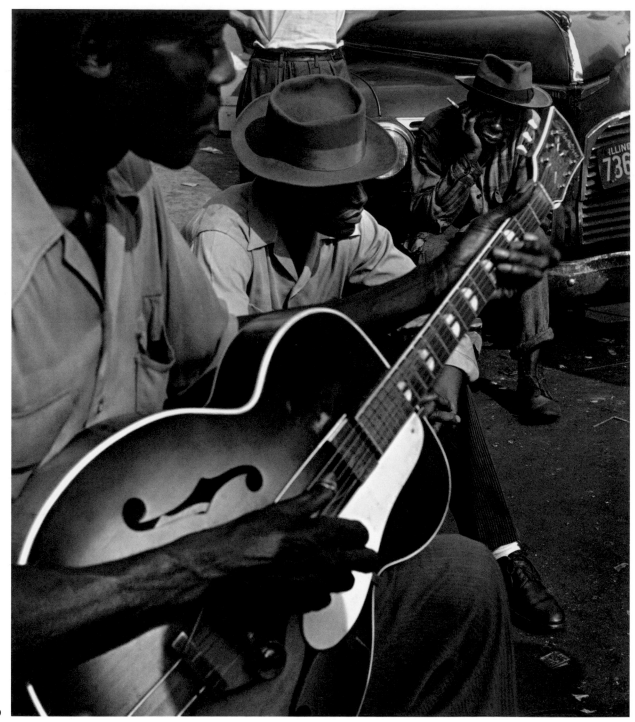

19

Blues at the Maxwell Street flea market

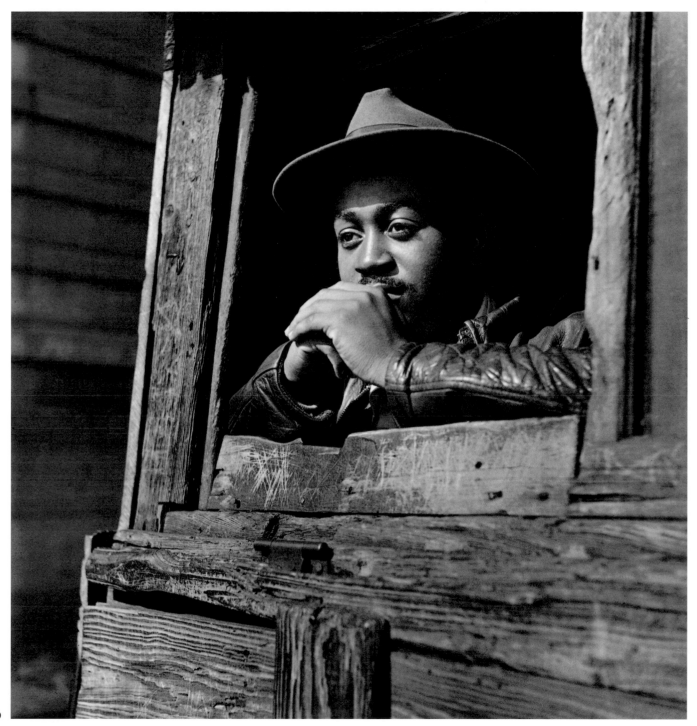

20

Man at window of shack

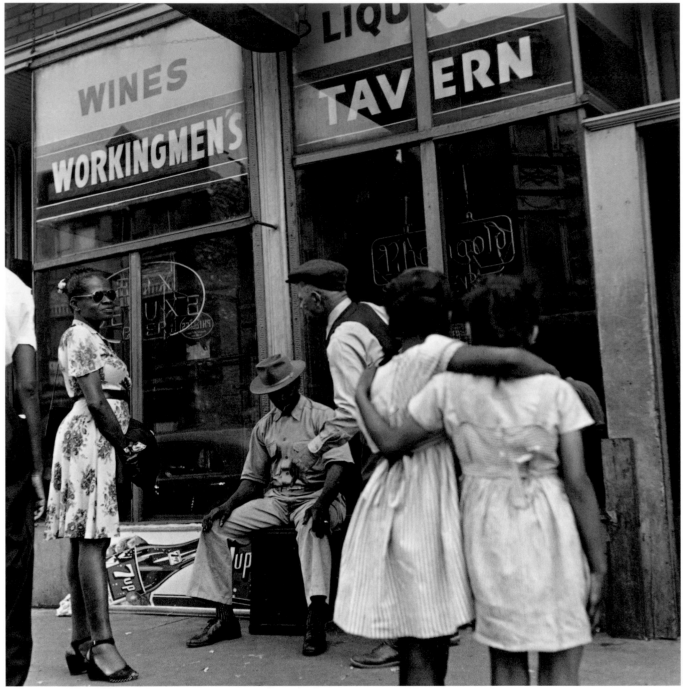

Two girls waiting outside a tavern

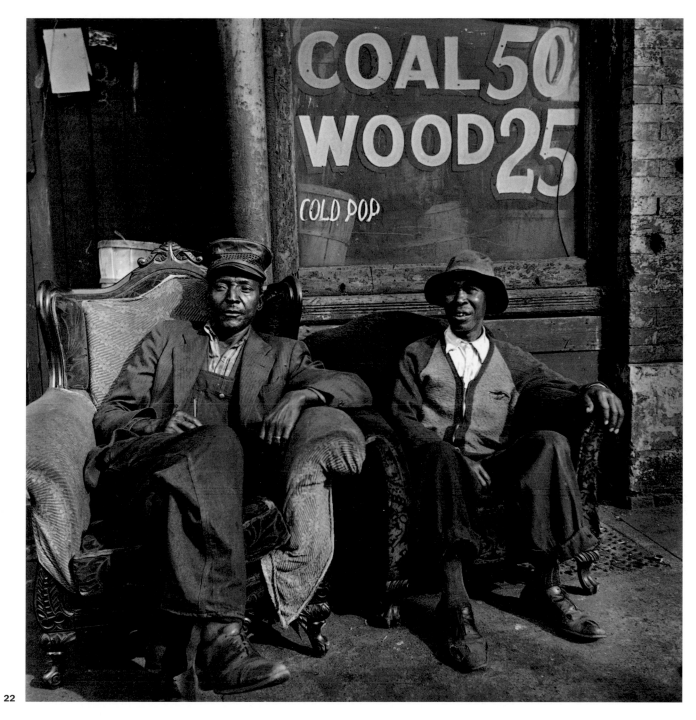

Merchants, South Halsted Street

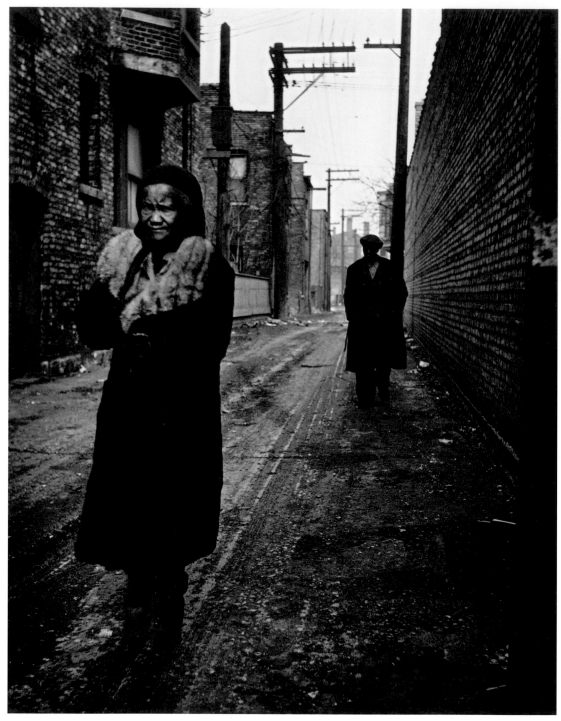

Two walkers. Alleys were important thoroughfares.

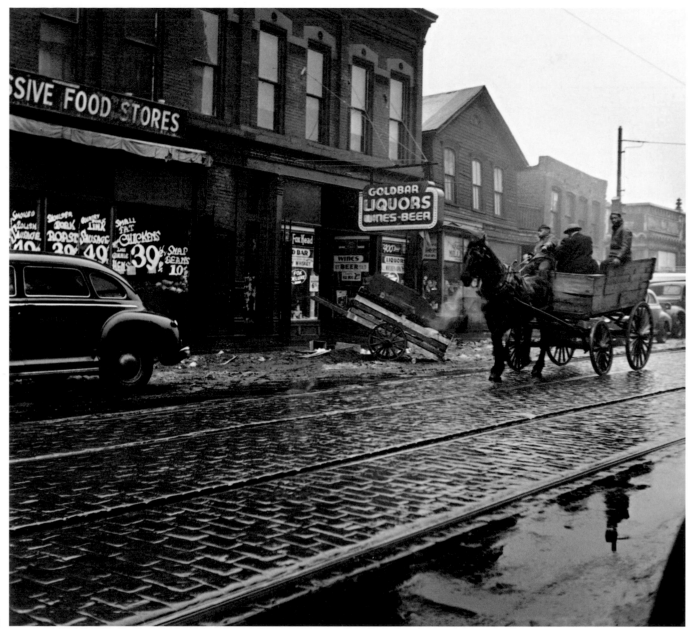

"When the wagon wheels are in the
streetcar tracks, it's like floating on air."

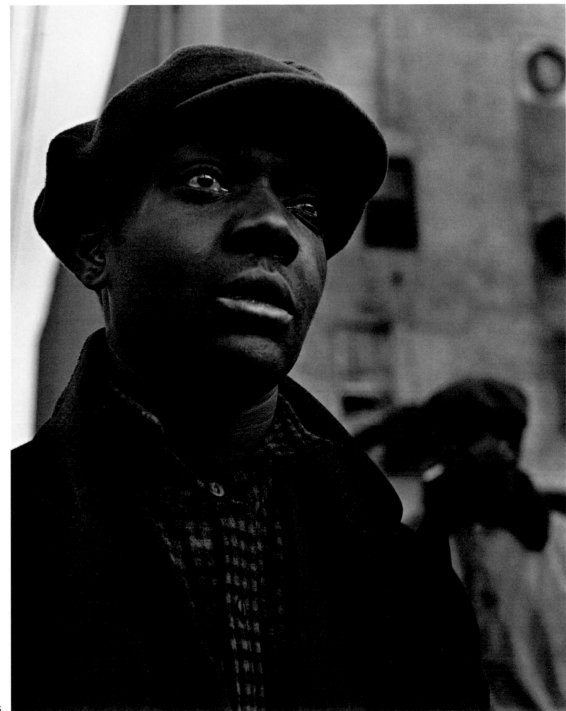

25

Striker on picket line of packing
house workers, March 1948

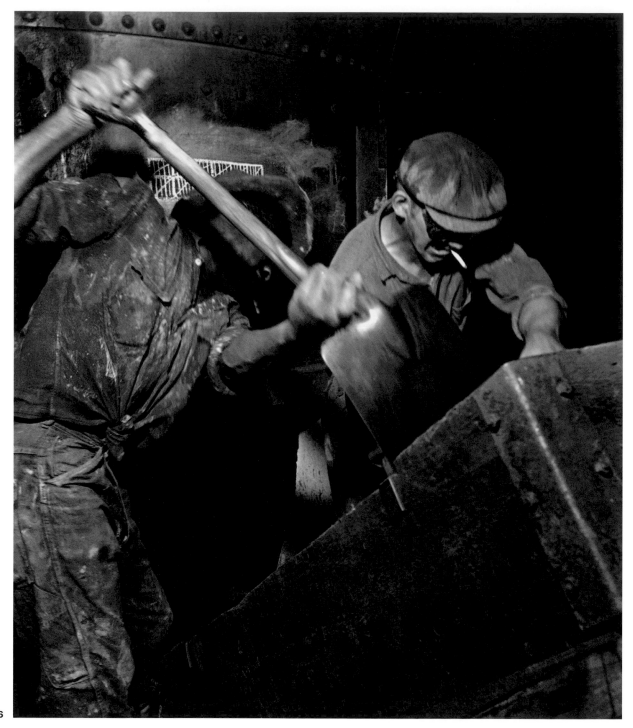

Workers shovel scrap metal at the International Harvester tractor works, making a chalk mark for each box emptied.

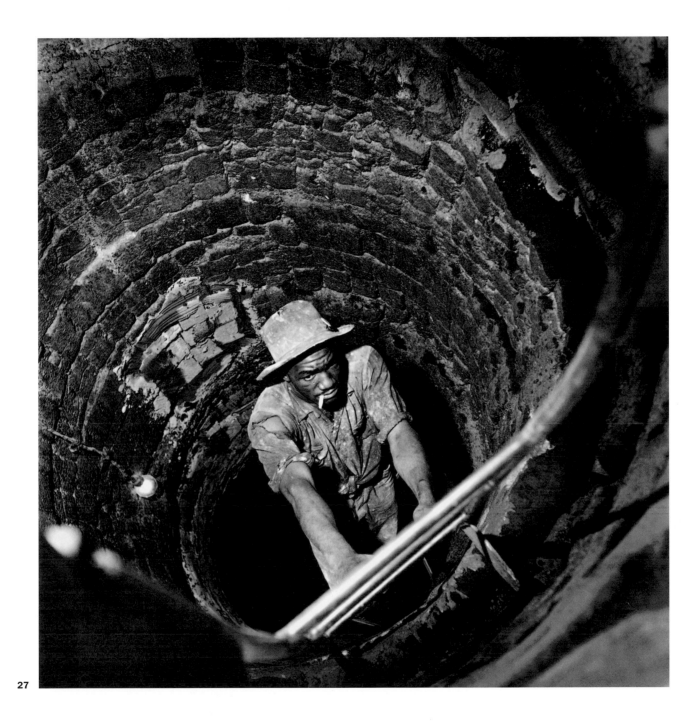

27

Repairing the furnace chimney

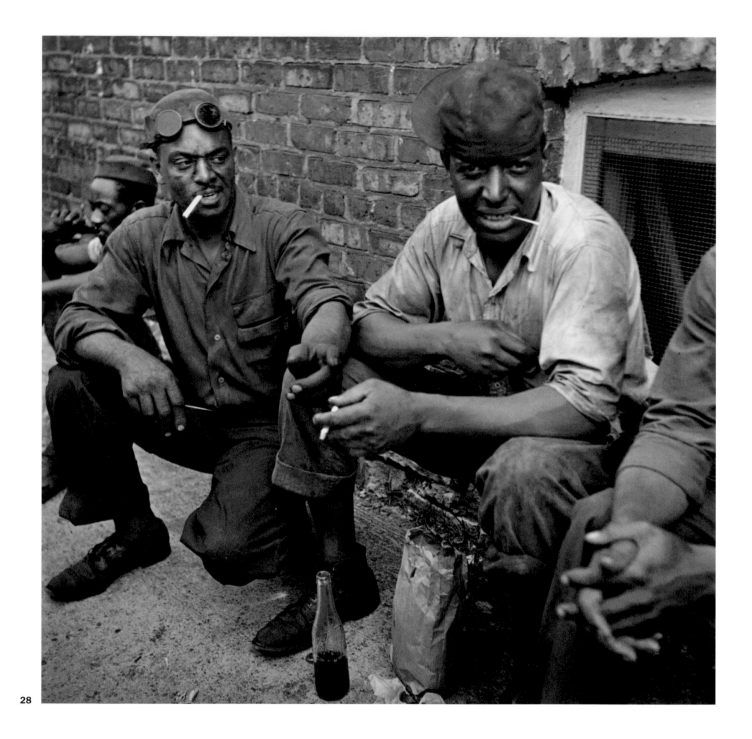

Lunch break

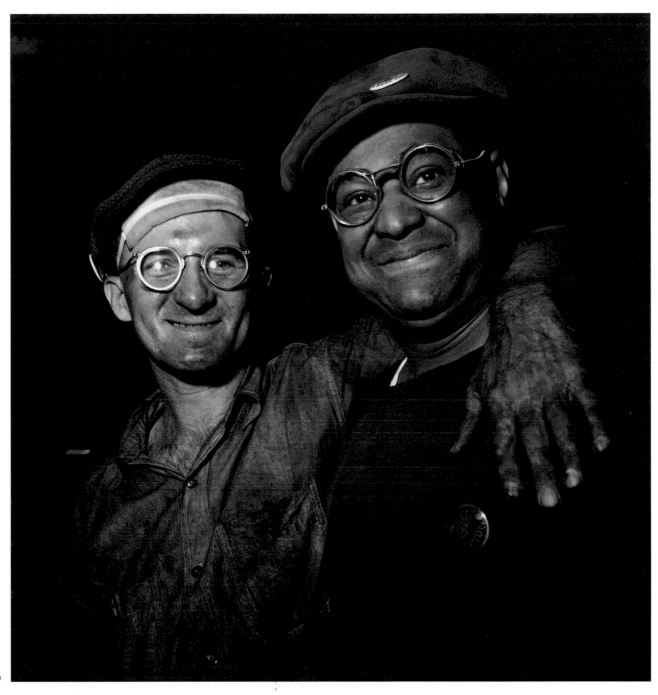

29

Black safety inspector, the supervisor of his
white coworker at International Harvester

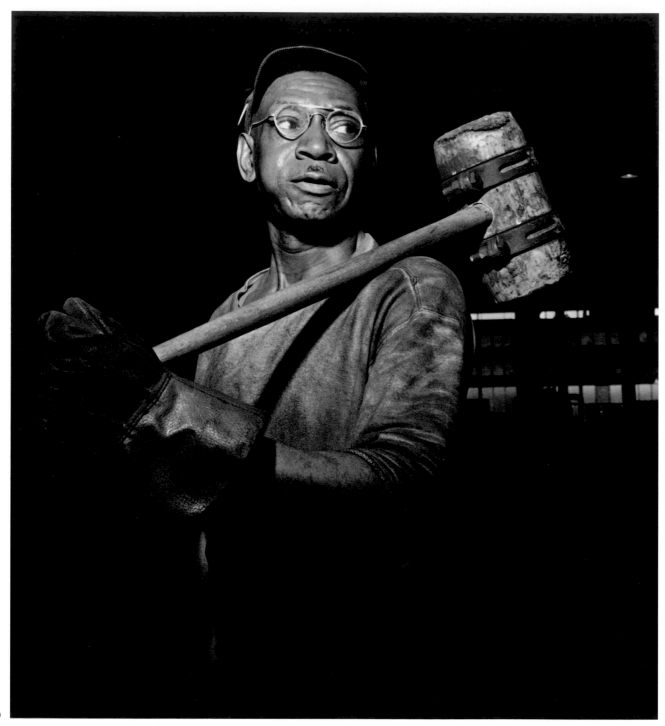

Mallet used to release cooling
tractor part castings from the mold

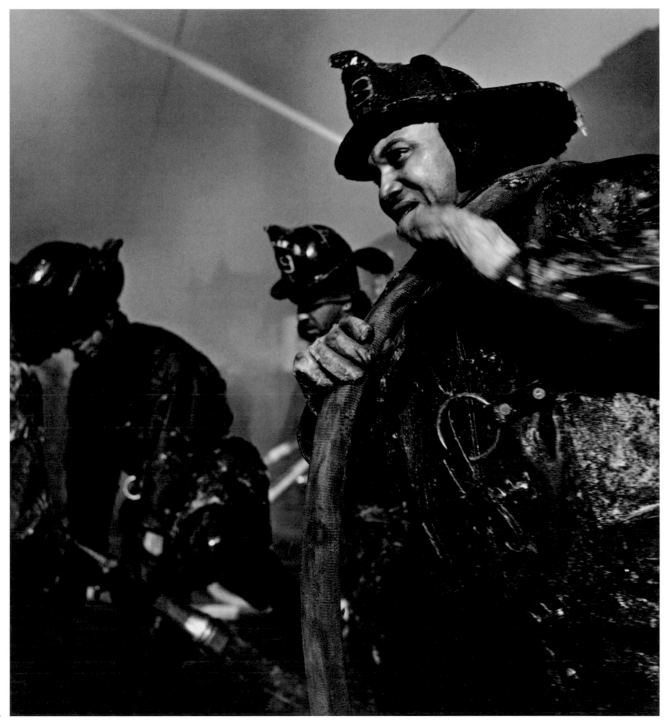

Company Nine battling a blaze
in sub-zero temperatures

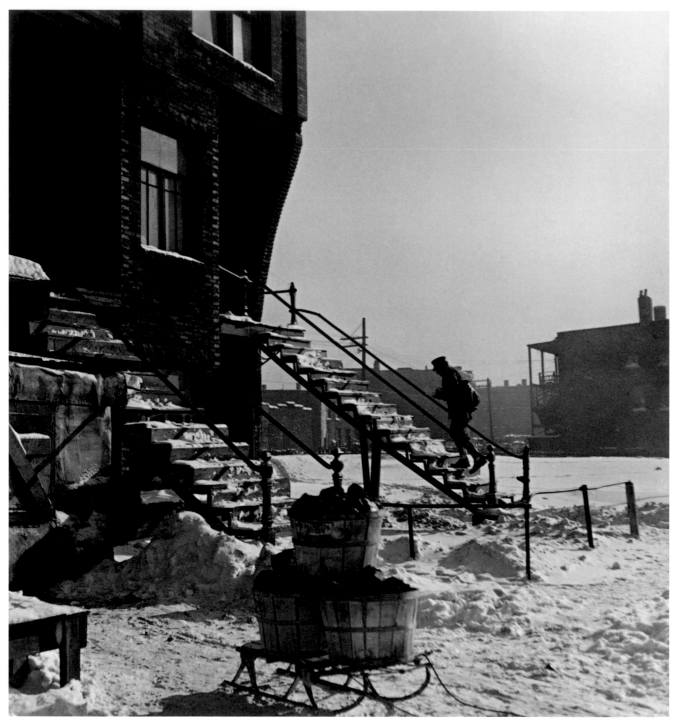

Coal delivery and postman

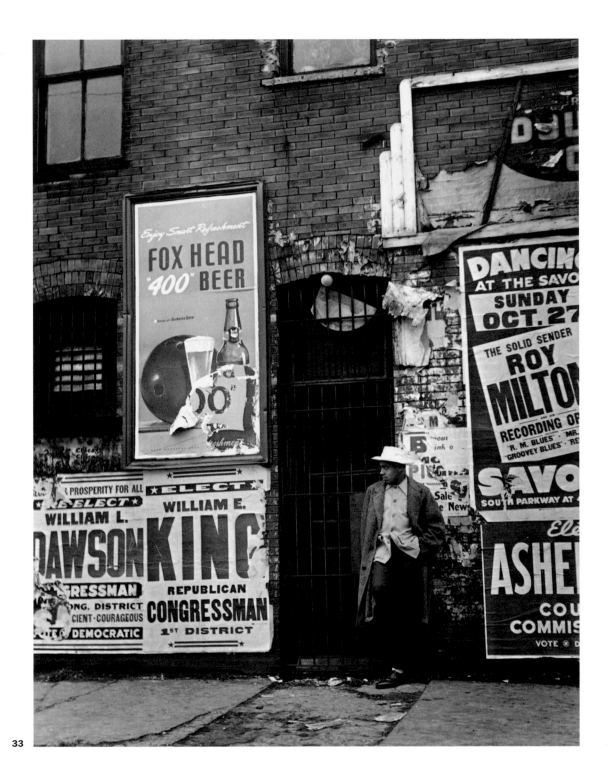

Man waiting on street

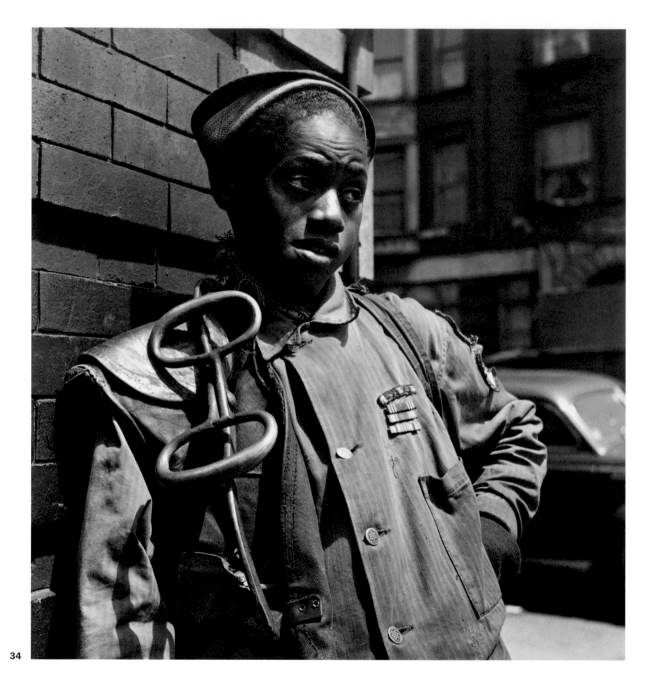

Young ice man, with World War II ribbons on his
jacket. The special leather shoulder pads allowed
him to carry ice up apartment stairs. A placard in
the window indicated how much ice was needed.

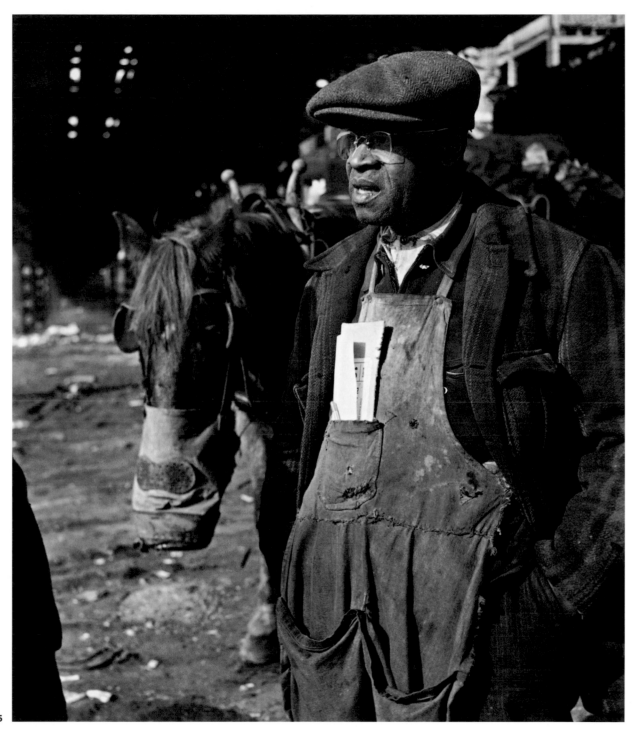

Delivery man and horse with nose
bag rest under elevated train tracks

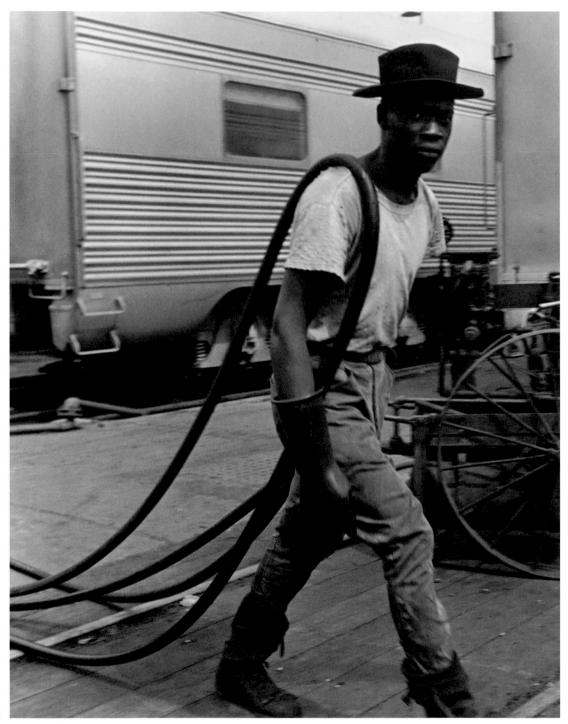

Railroad passenger car maintenance man.
Air hoses were used to clean the cars.

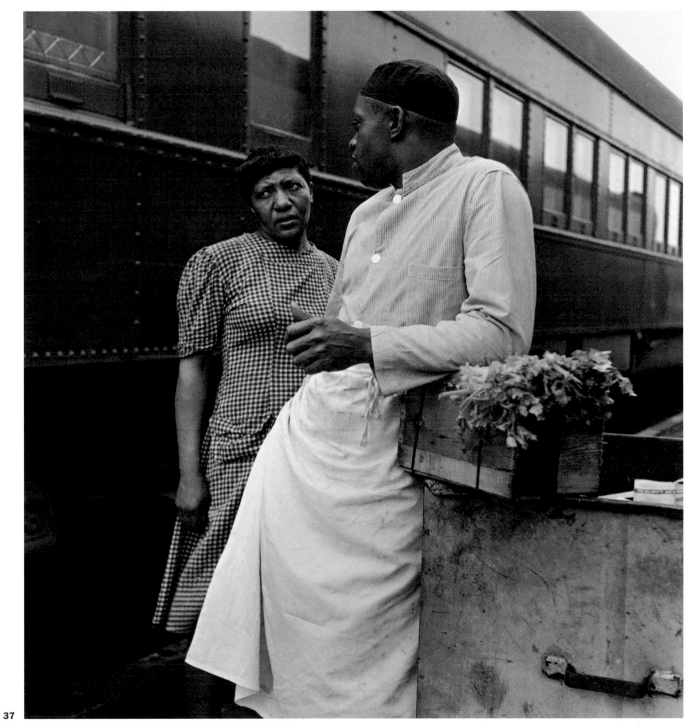

Dining car workers, Illinois Central Railroad

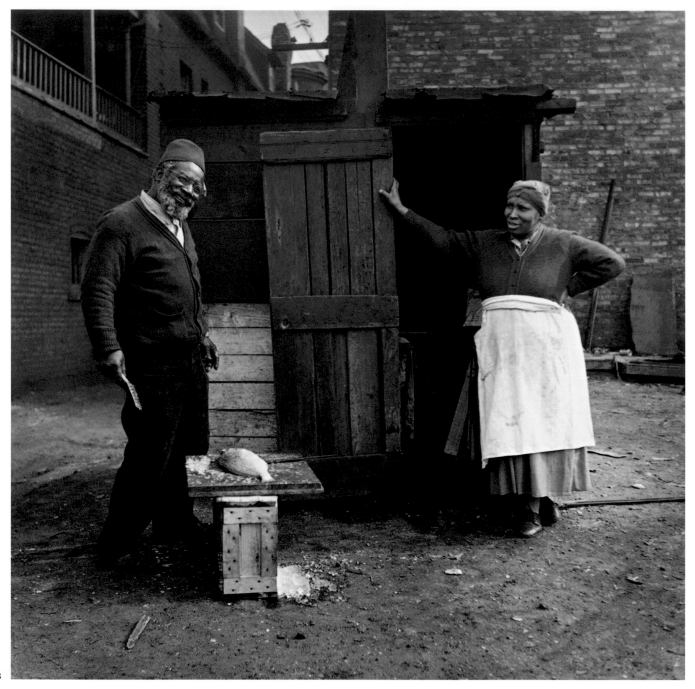

Selling fish from an alley shed

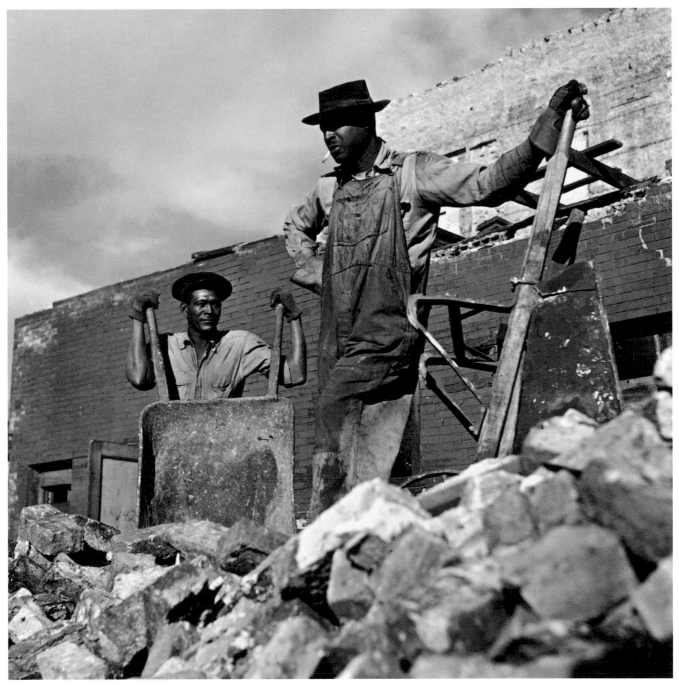

39

Workers demolishing building

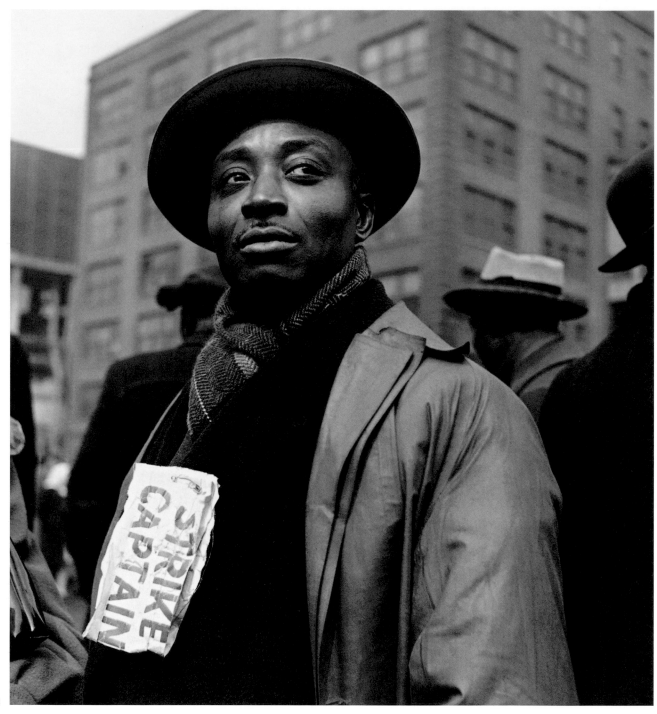

40

Strike captain during protest by the
packing house workers, March 1948

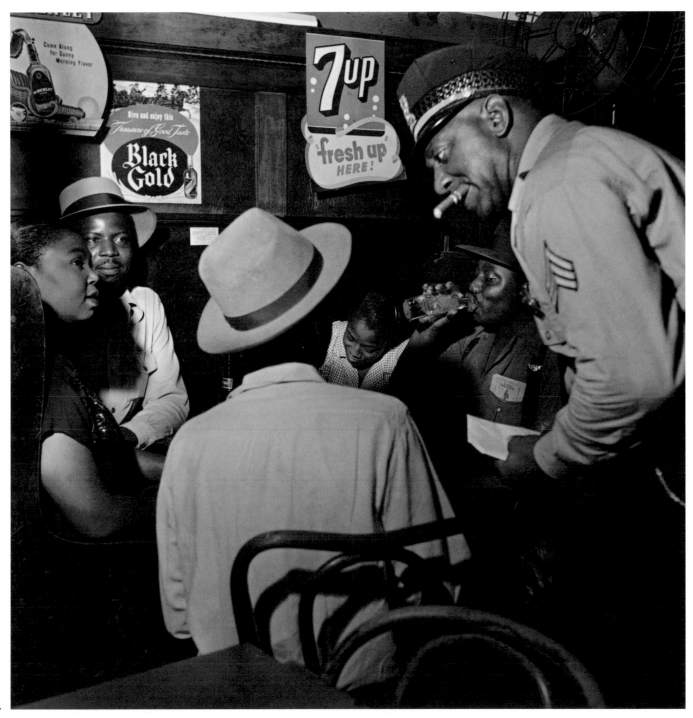

Chicago police sergeant
questioning bar patrons

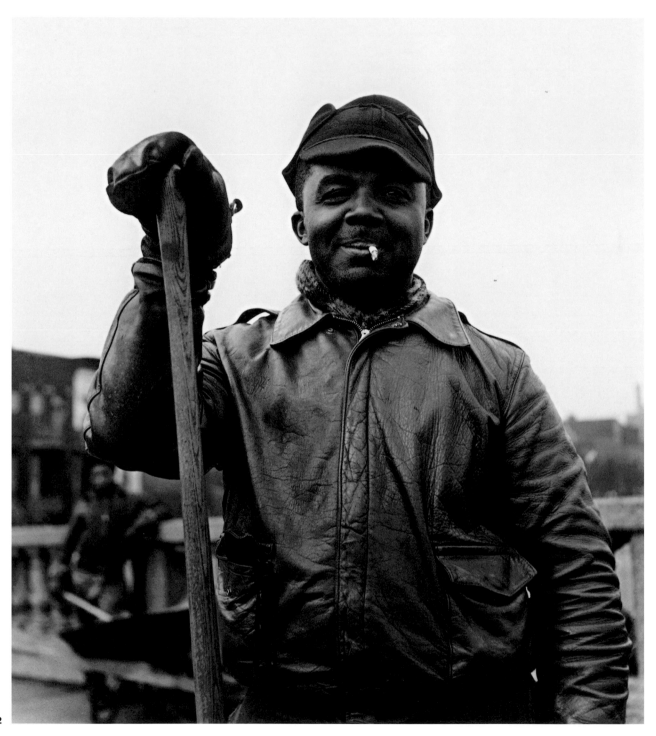

Street sweeper in World War II army
surplus leather jacket

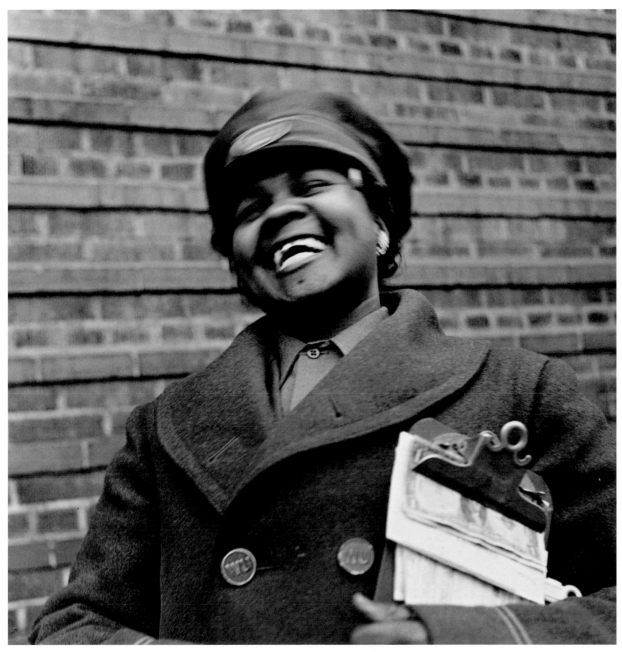

43

Western Union telegram messenger

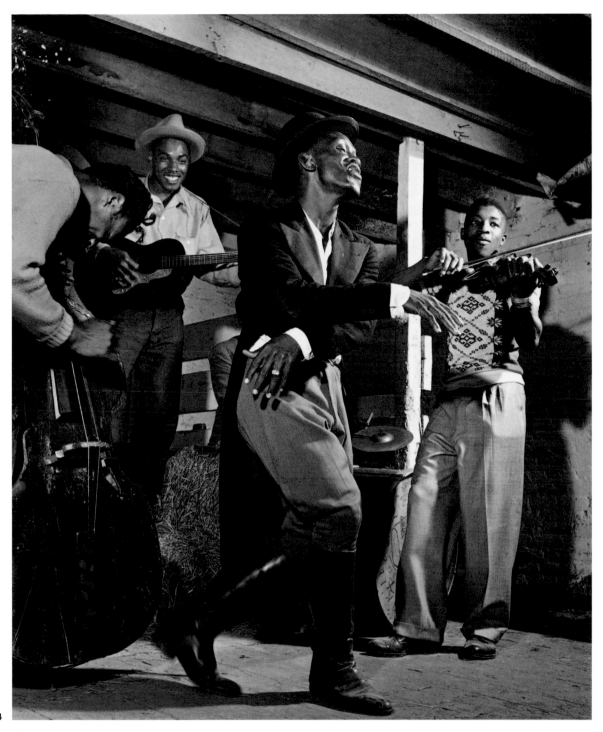

Impromptu hoedown on the third
floor of a horse barn

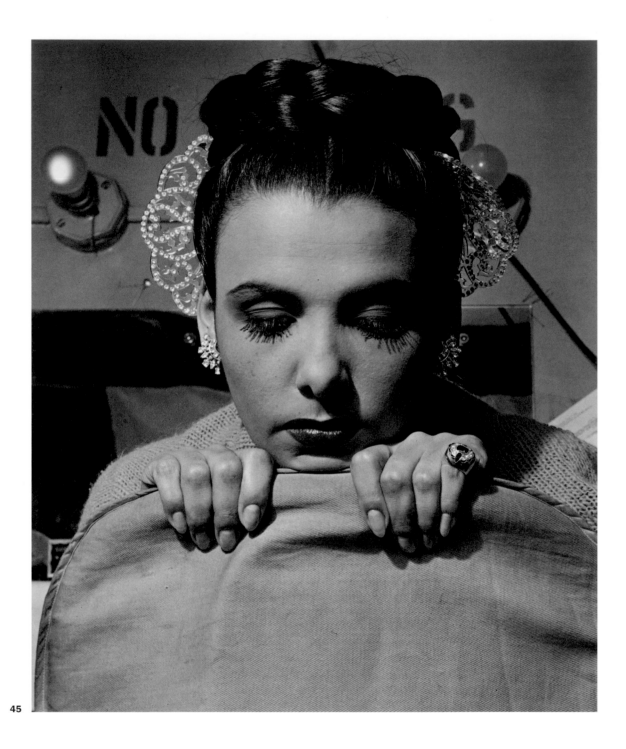

45

Lena Horne backstage at the
Chez Paree, May 1947

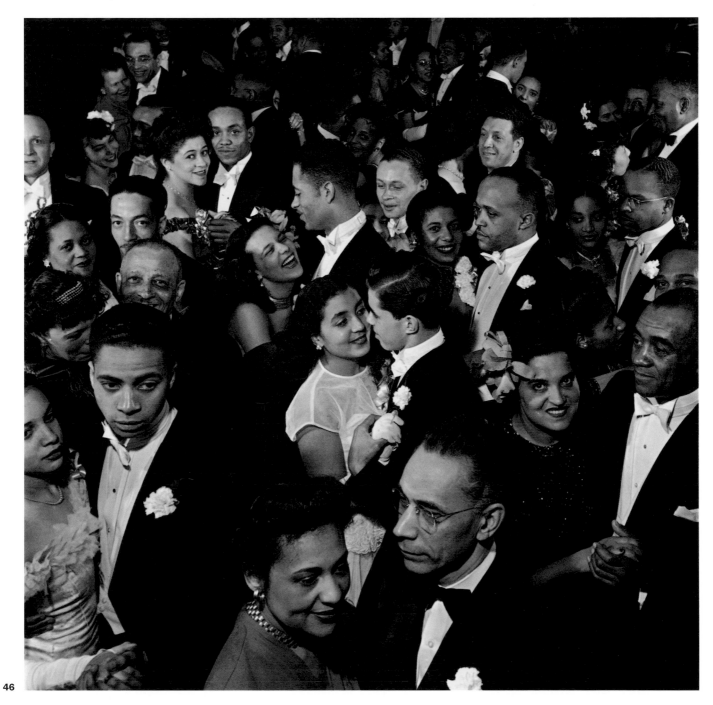

Debutante ball sponsored by the "Royal Coterie of Snakes," an exclusive gentleman's club, at the Parkway Ballroom, December 1946

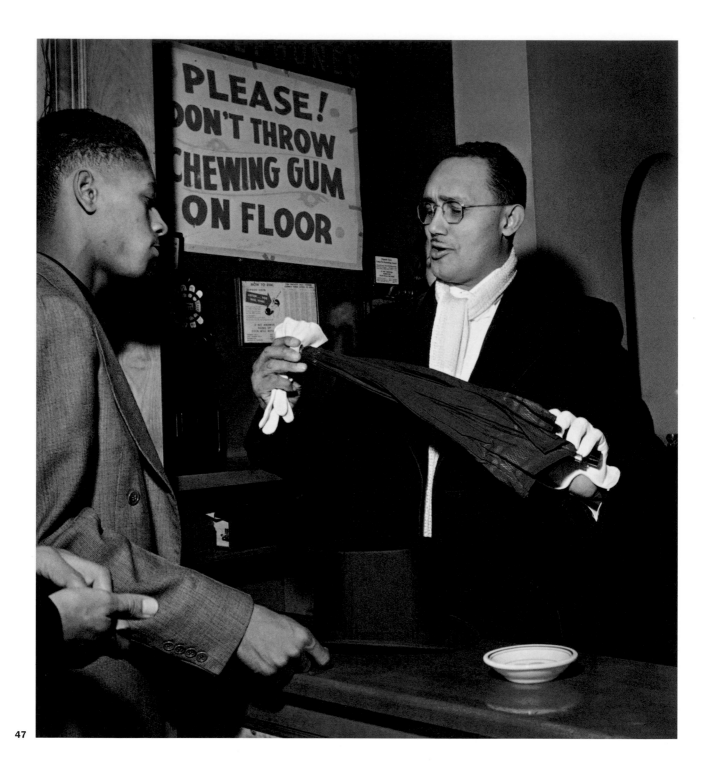

Check room at the Parkway Ballroom

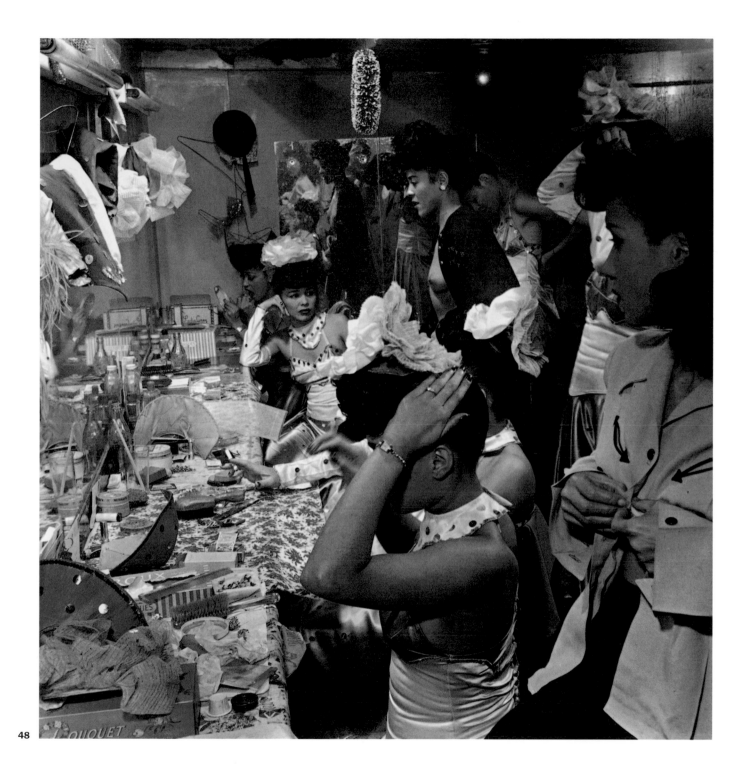

Chorus girls backstage at the Rum Boogie Club

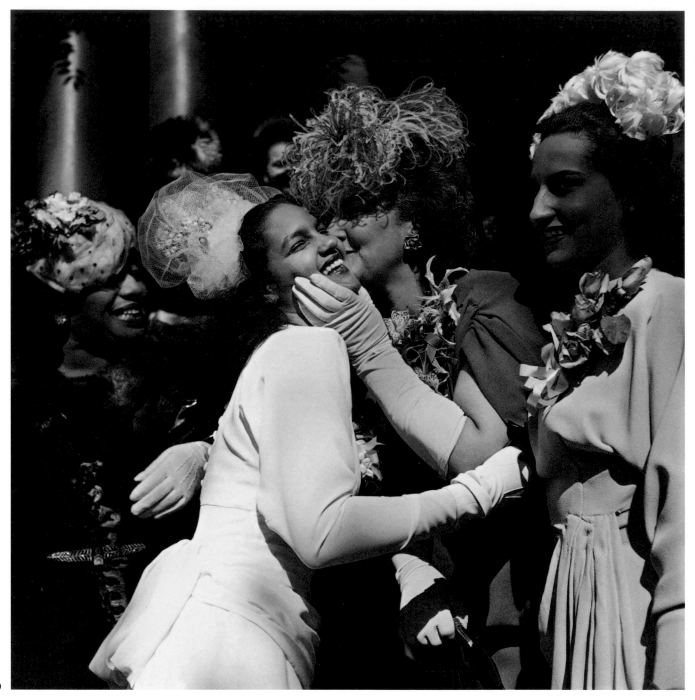

49

Wedding

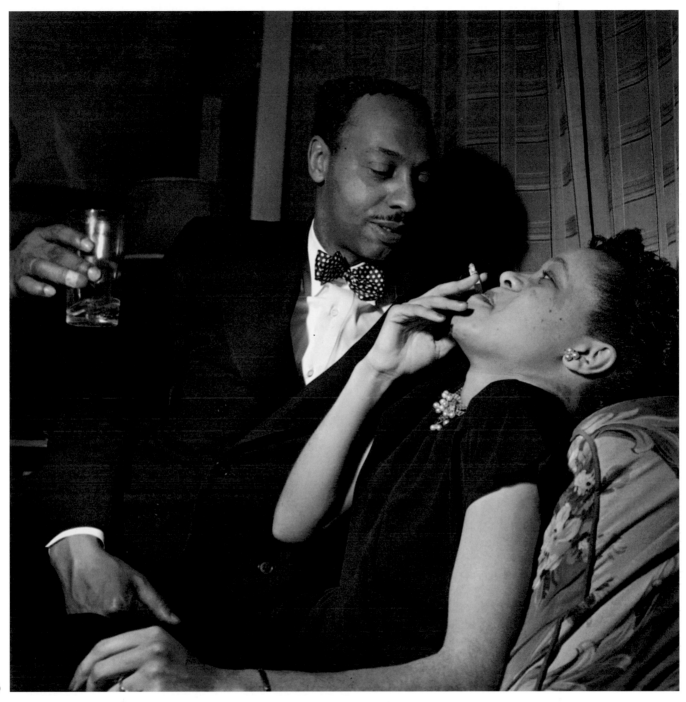

Party at the Parkway Community House, 1947

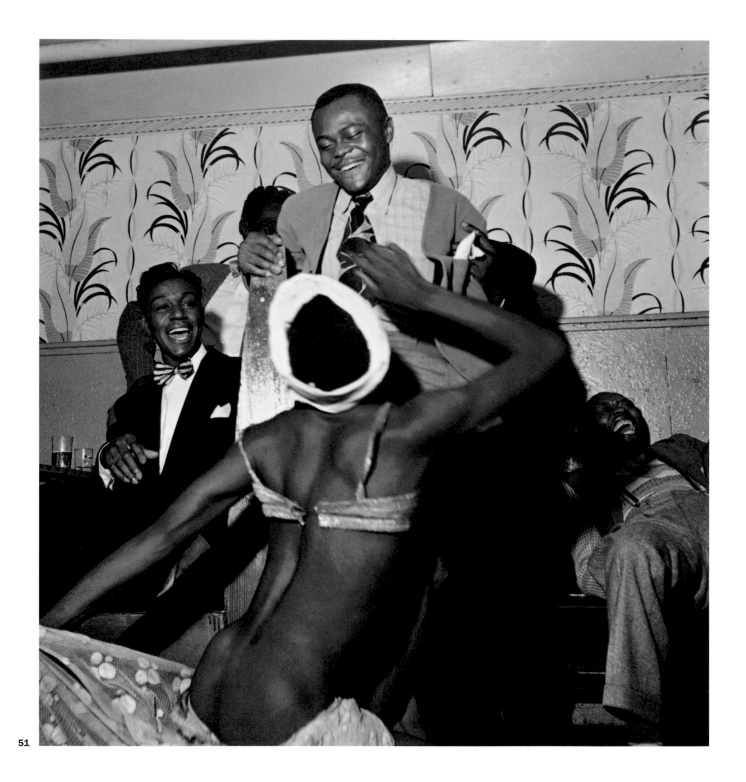

51

Female impersonator

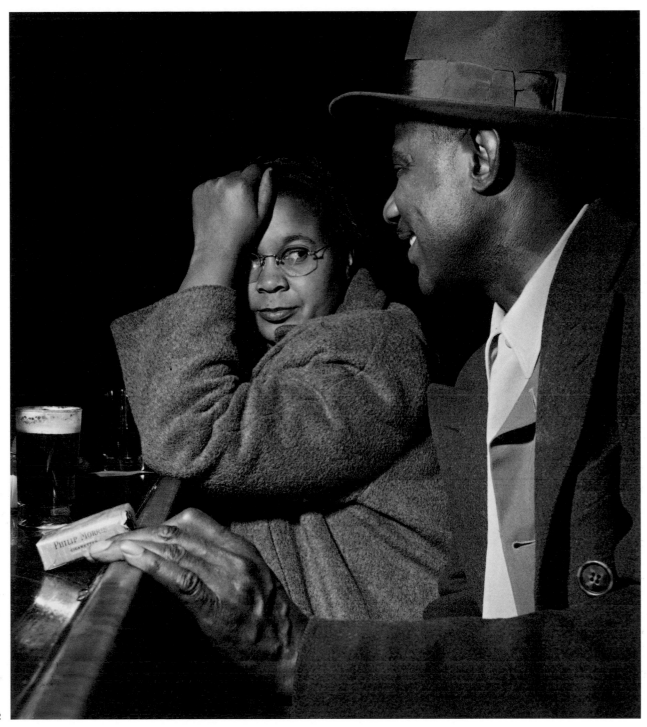

An afternoon beer

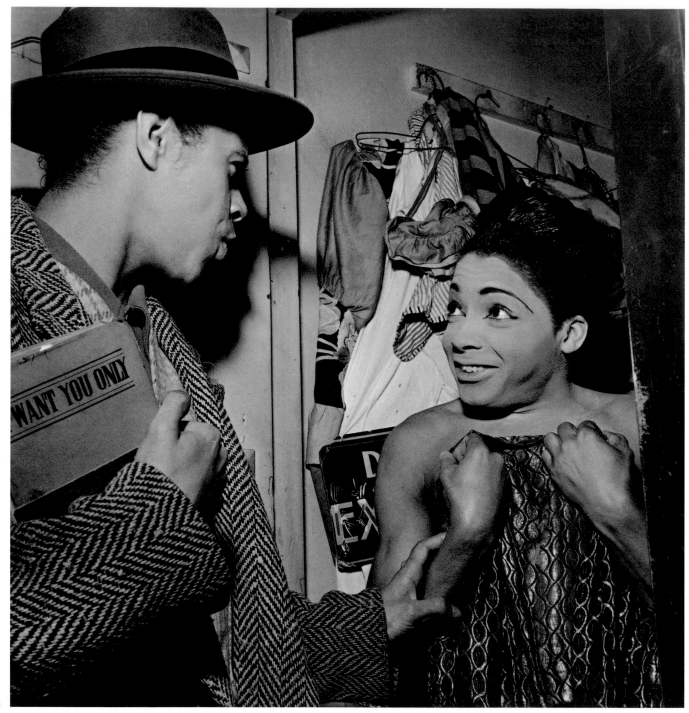

53

Female impersonator dressing for a
performance at Joe's DeLuxe Club

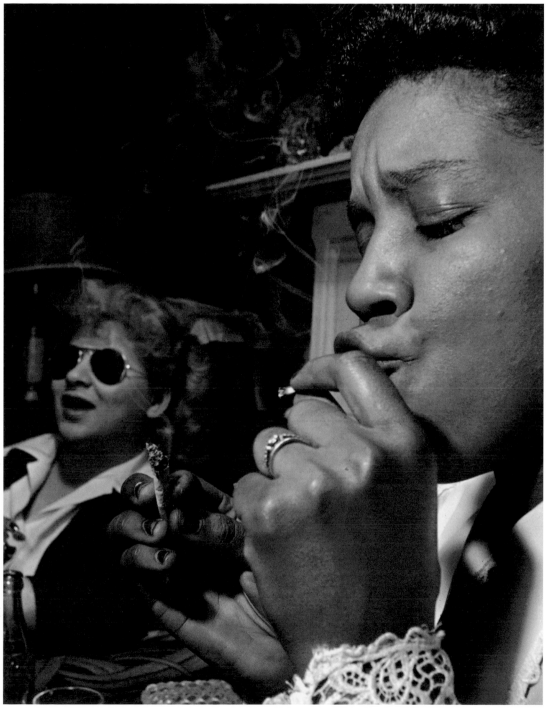

54

"Reefer party"

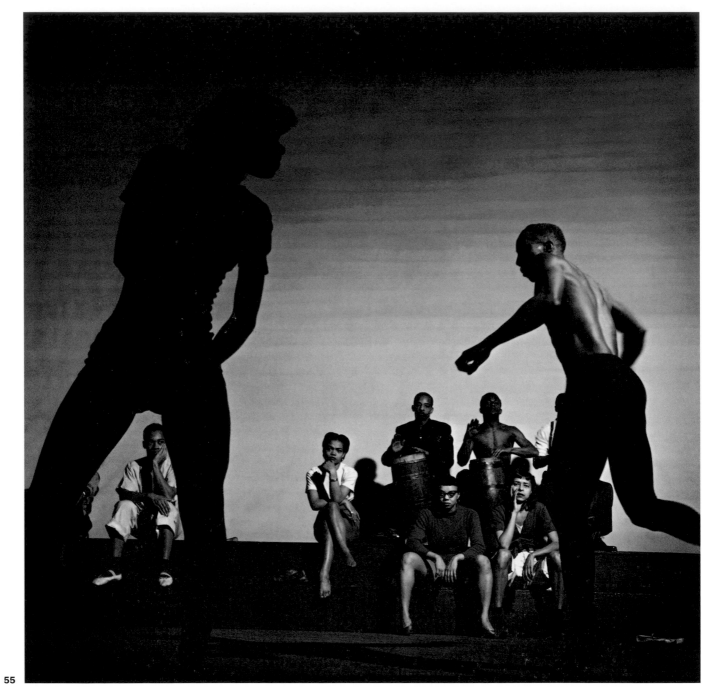

55

Eartha Kitt (center) leading a dance
troupe rehearsing for the Chez Paree

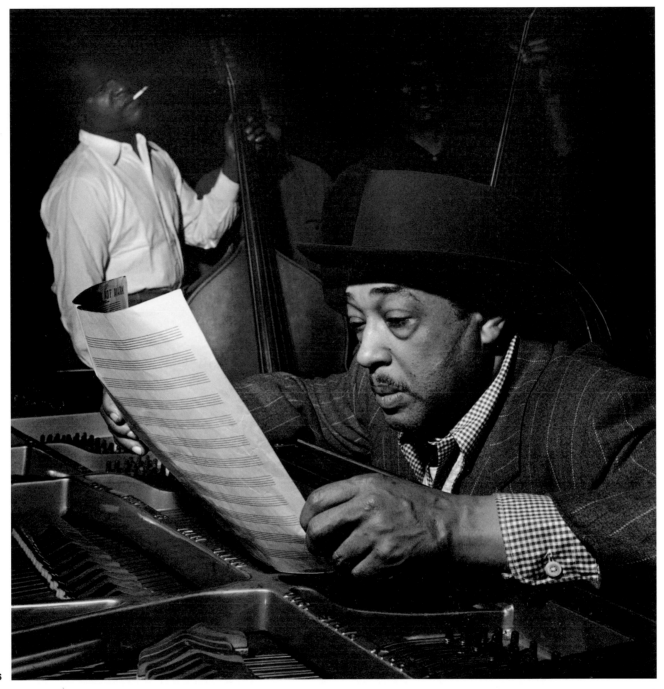

Duke Ellington rehearsing
on stage at The Savoy

57

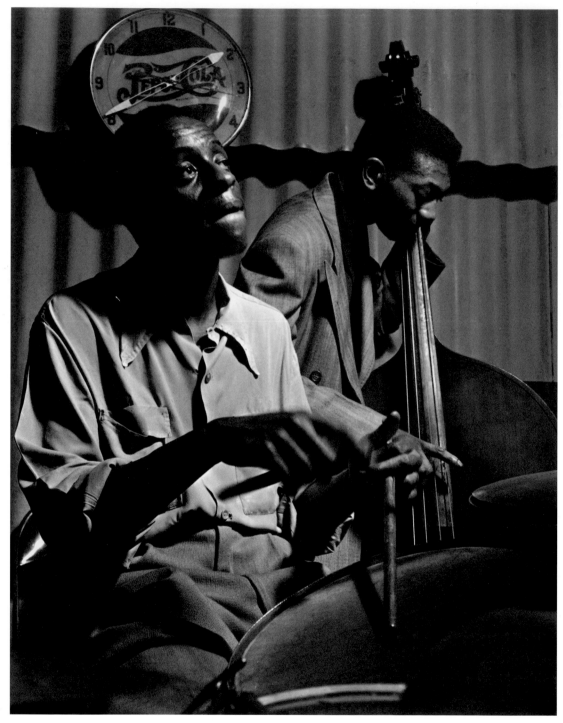

Two musicians, 1:40 A.M.

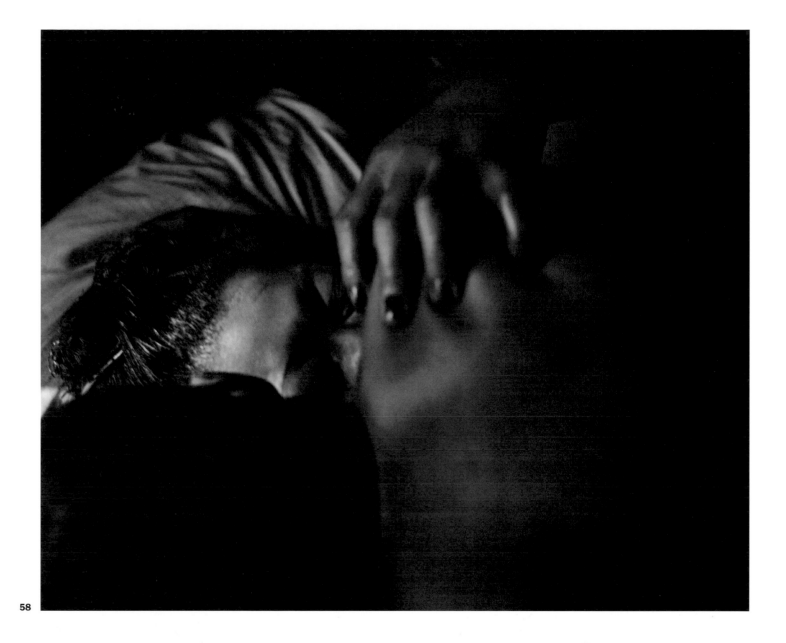

58

Tuesday afternoon on South Halsted Street

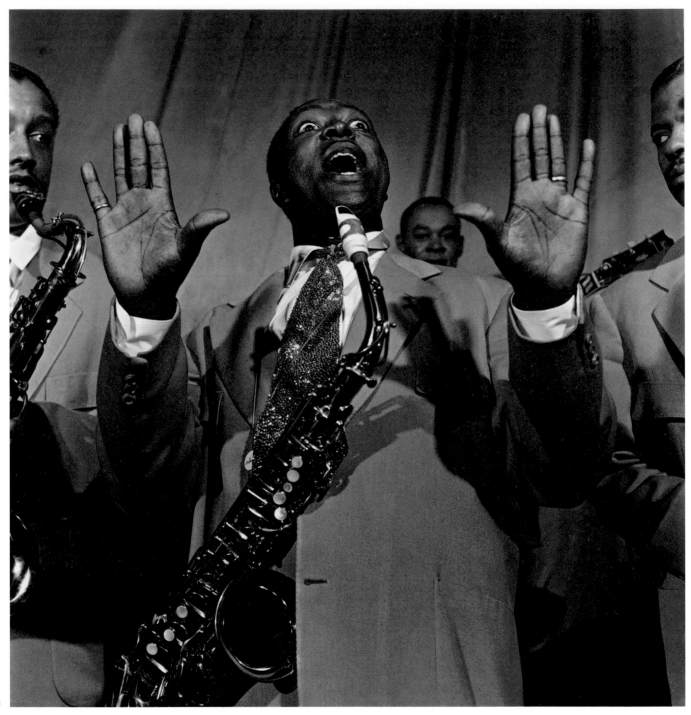

59

Louis Jordan, a popular musician who had a flair
for putting advice for the lovelorn into his lyrics

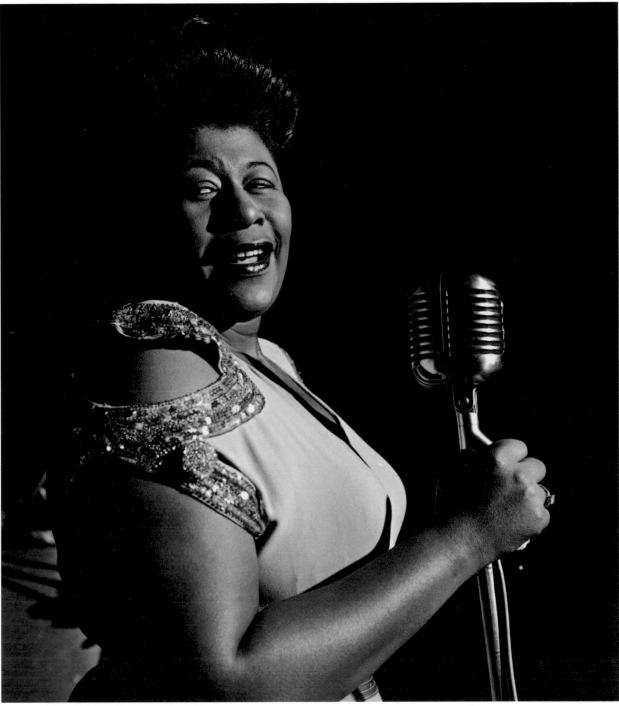

Ella Fitzgerald performing, 1948

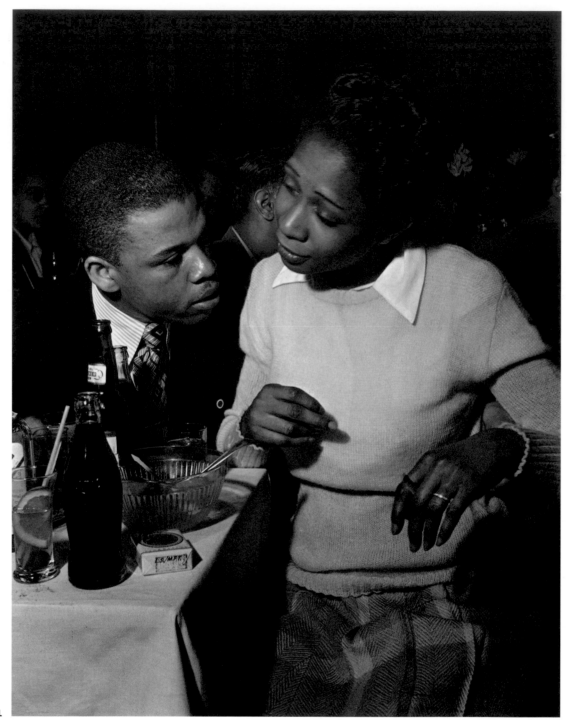

Moving to music

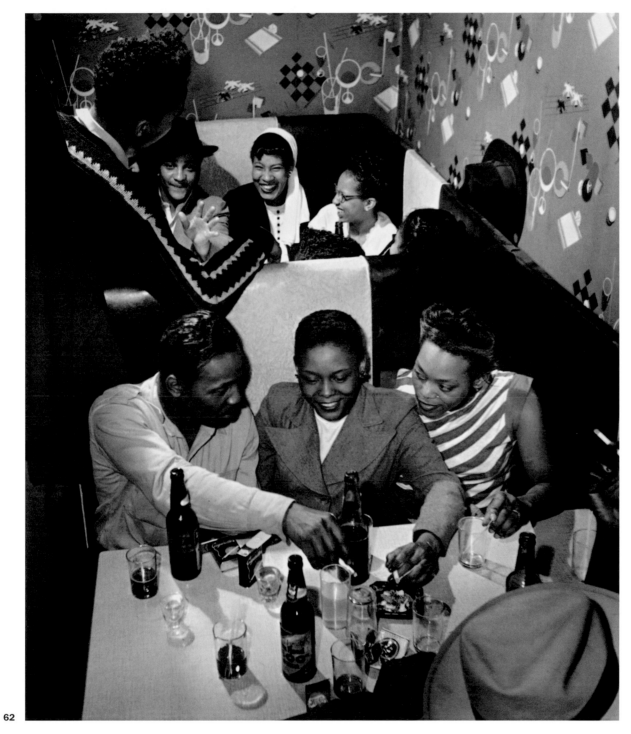

Neighborhood tavern

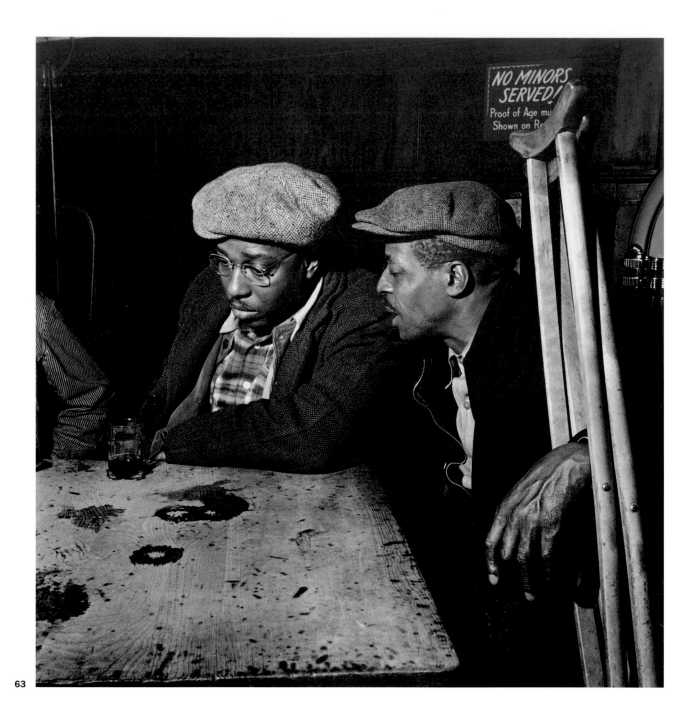

63

Serious conversation

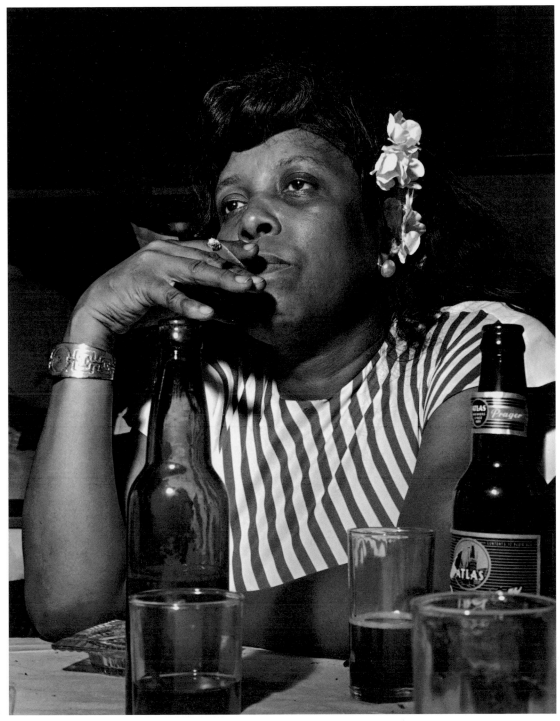

Waiting

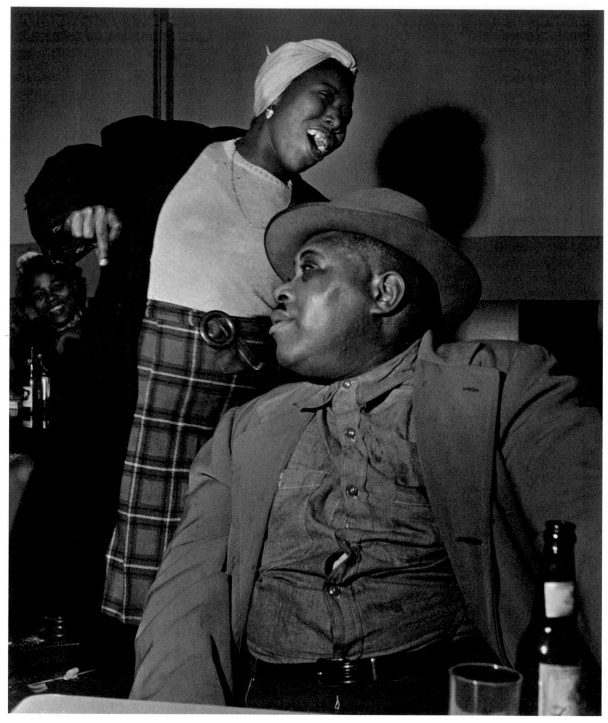

65

Dancing at the 45th Street bar that
catered to slaughterhouse workers

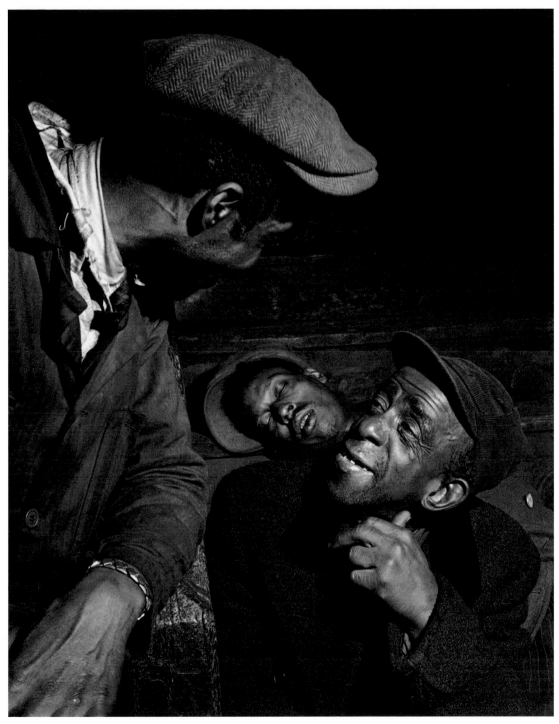

Back steps of the 45th Street bar

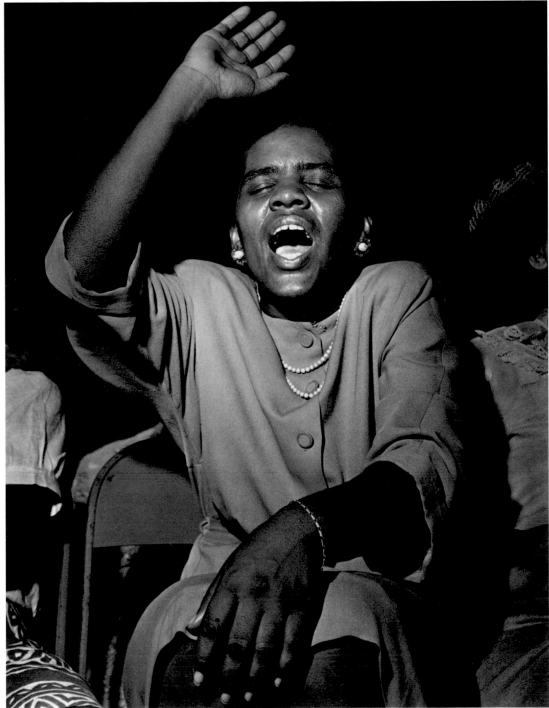

67

Gospel services

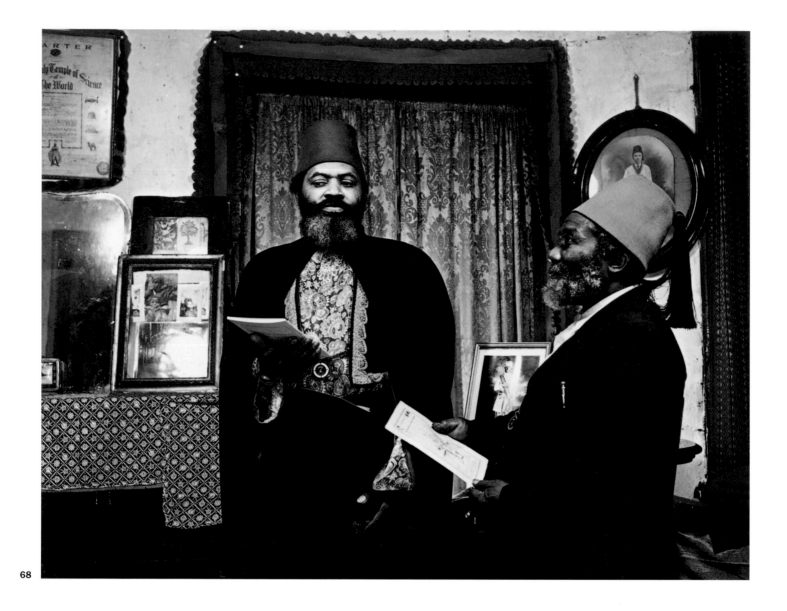

68

Followers of the Holy Temple of
Science of the World

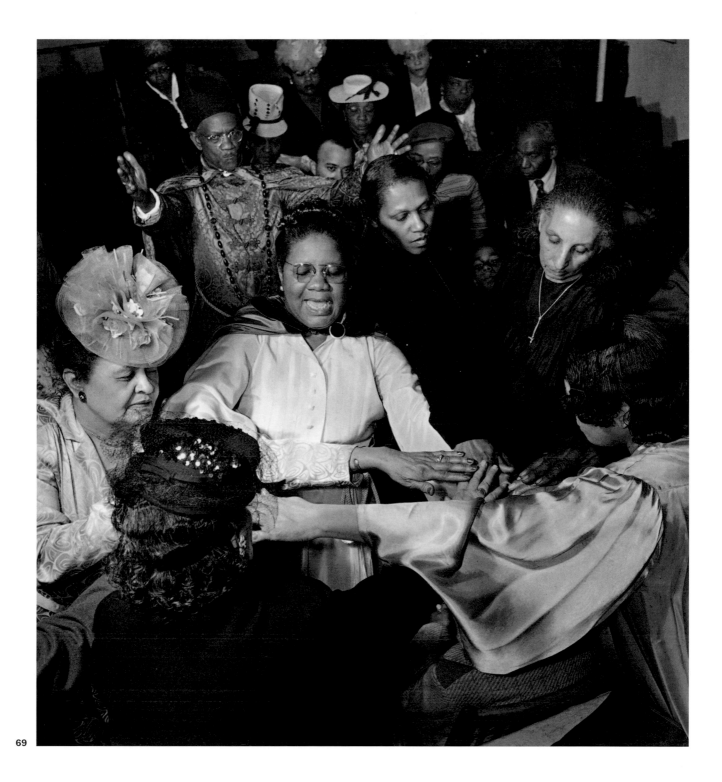

Prayer meeting

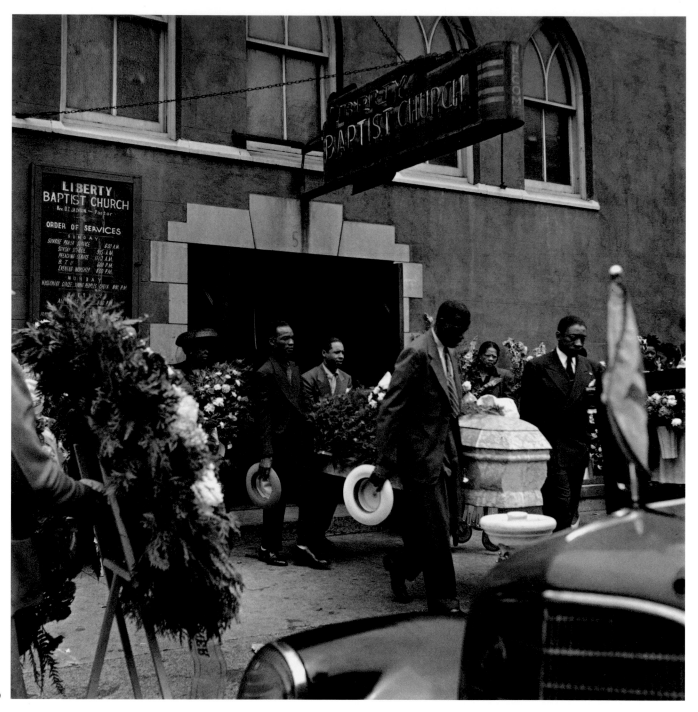

Pallbearers for a funeral at the
Liberty Baptist Church

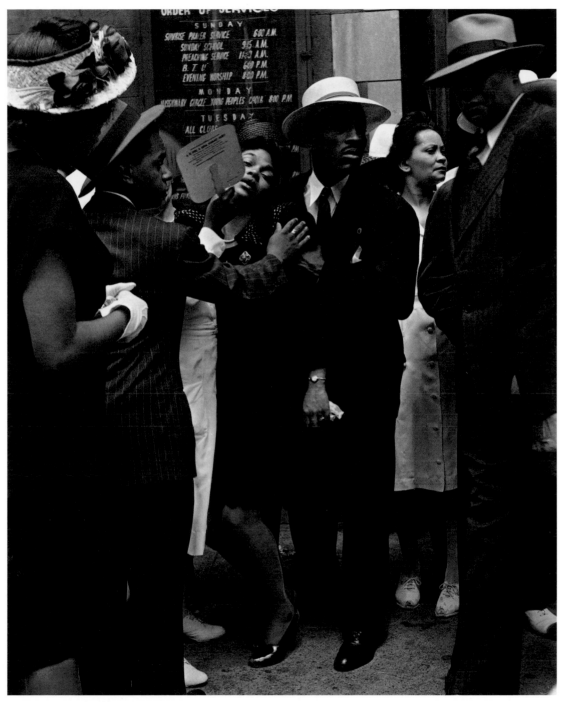

71

Mourners at funeral

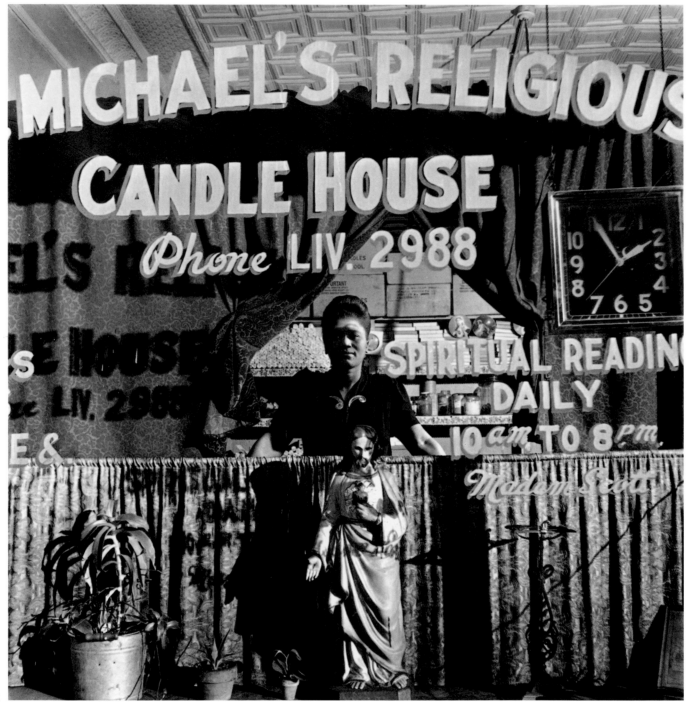

Spiritualist

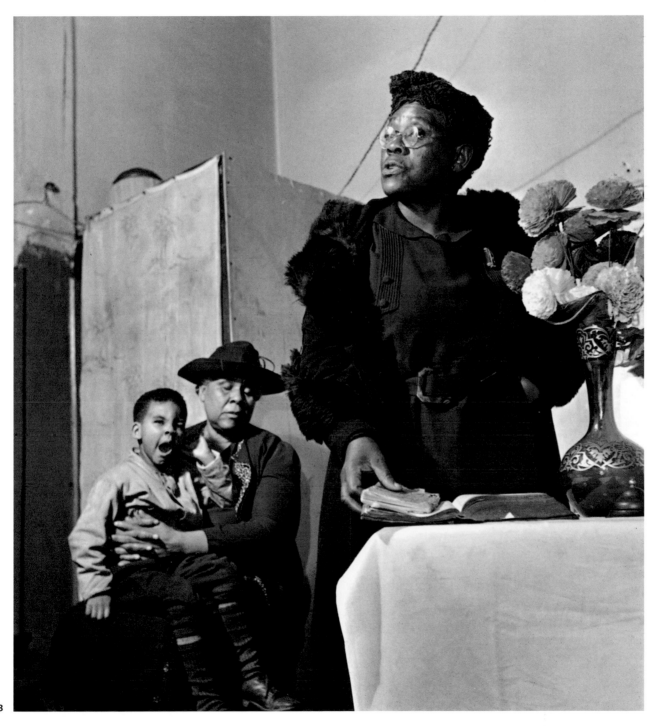

Wednesday night Bible class at
a storefront church

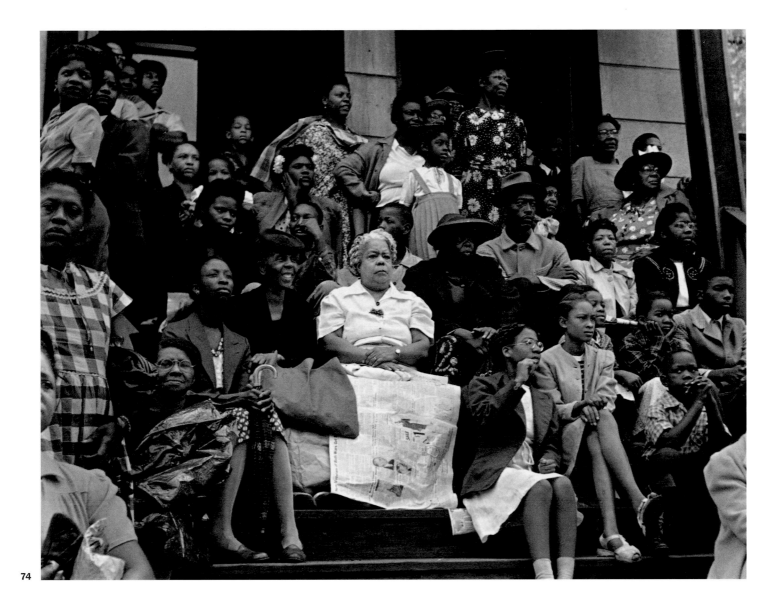

Parade watchers

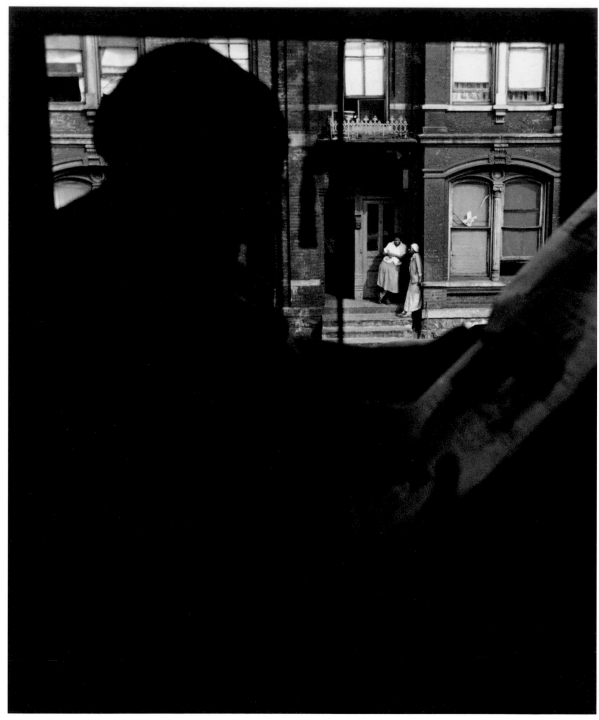

Through a bedroom window

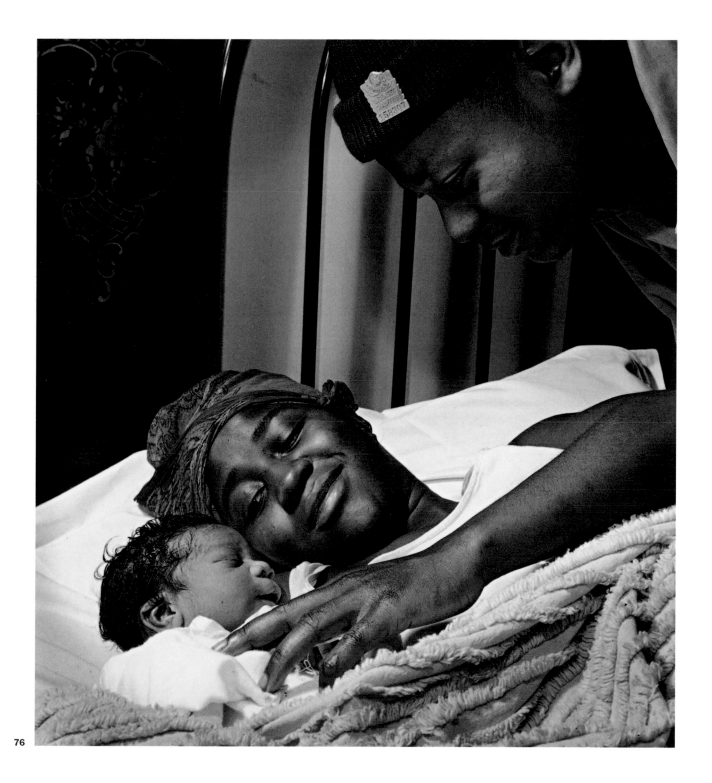

Vivian Henley, two hours old. Infants delivered at home by the Maxwell Street Maternity Center medical team had a better survival rate than those at most hospitals.

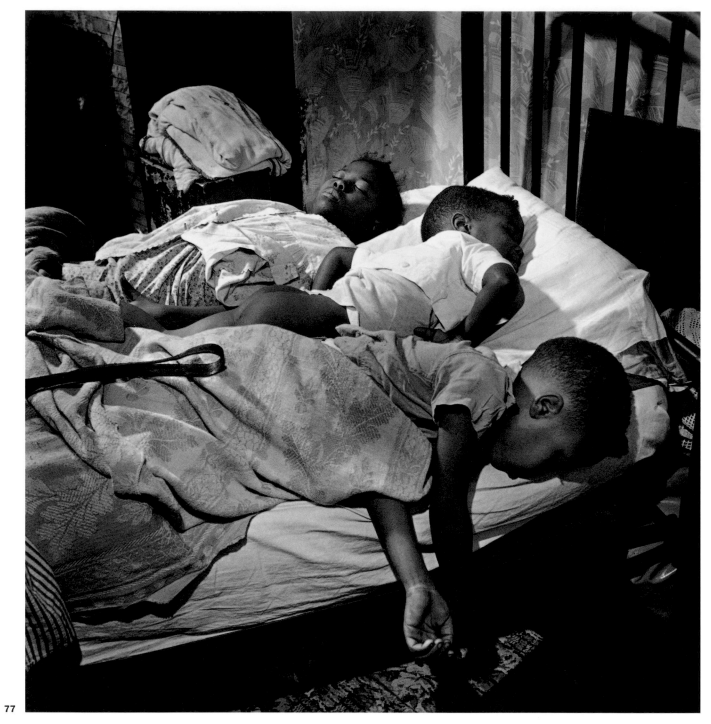

Sometimes a father would put his belt on a child's back as a warning to go to sleep or face punishment.

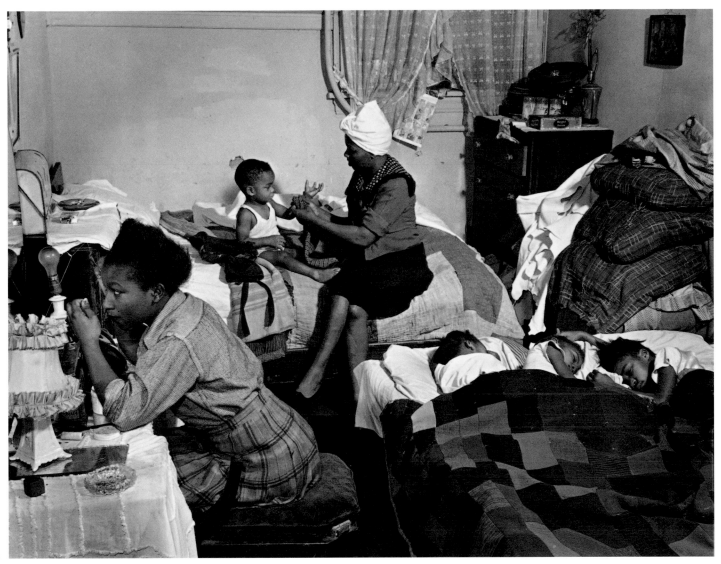

78

One-room kitchenette

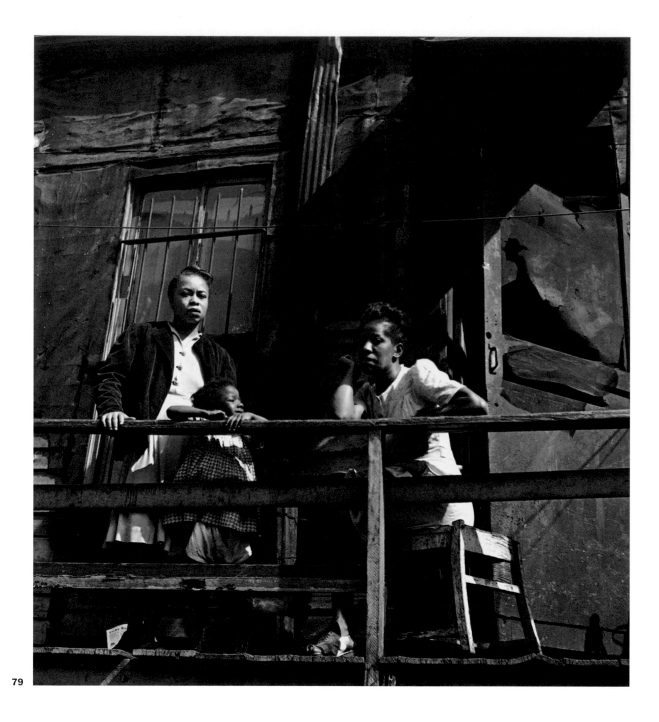

Tenement back porch

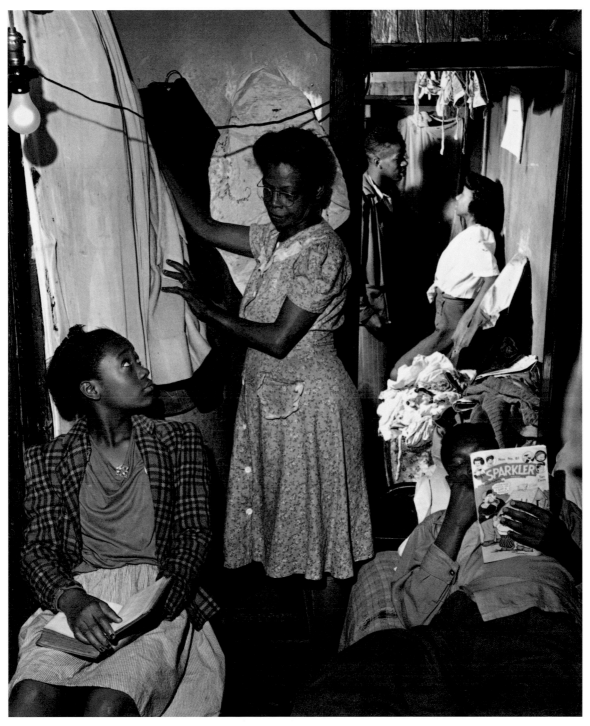

This basement apartment was condemned. The widow had nowhere to move with her three children.

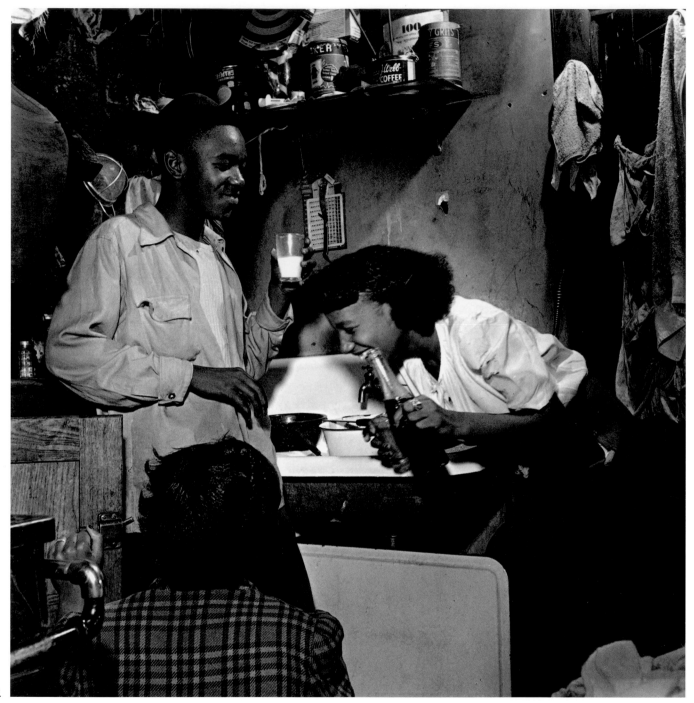

Three teenagers in kitchenette apartment

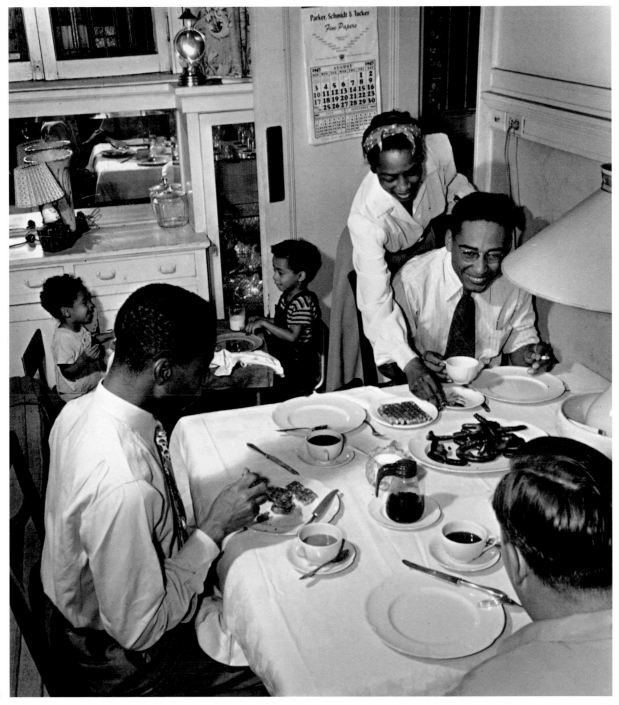

University of Chicago anthropologist St. Clair
Drake (rear) entertaining Bucklin Moon (front),
an editor from Houghton-Mifflin publishers

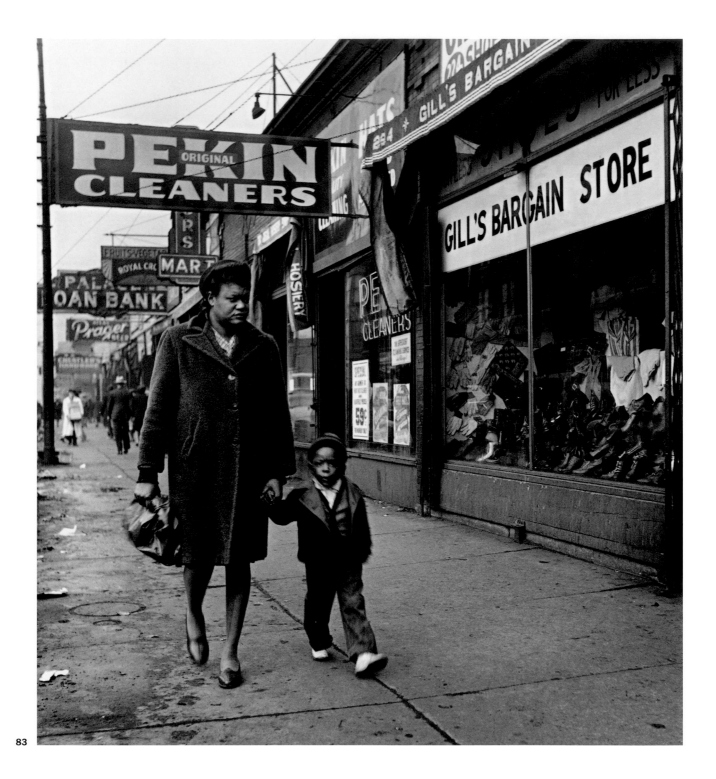

83

Mother and son

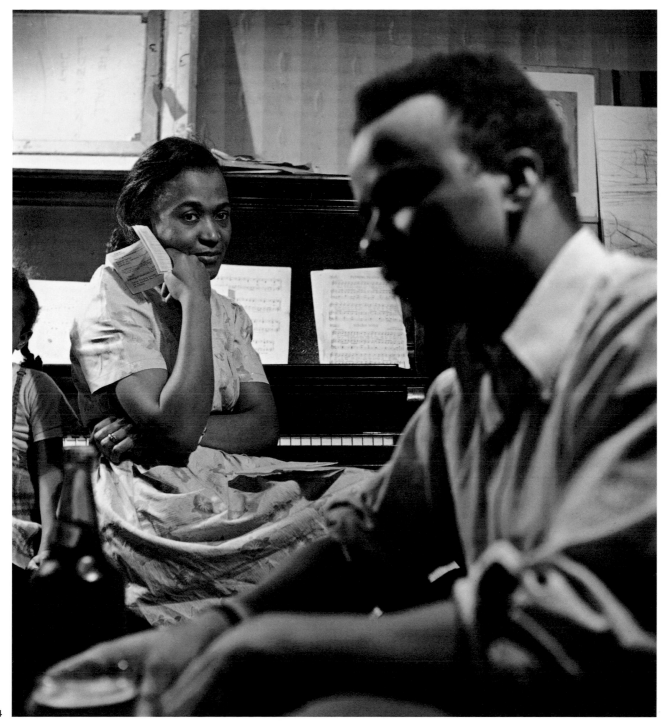

84

Husband and wife and bills

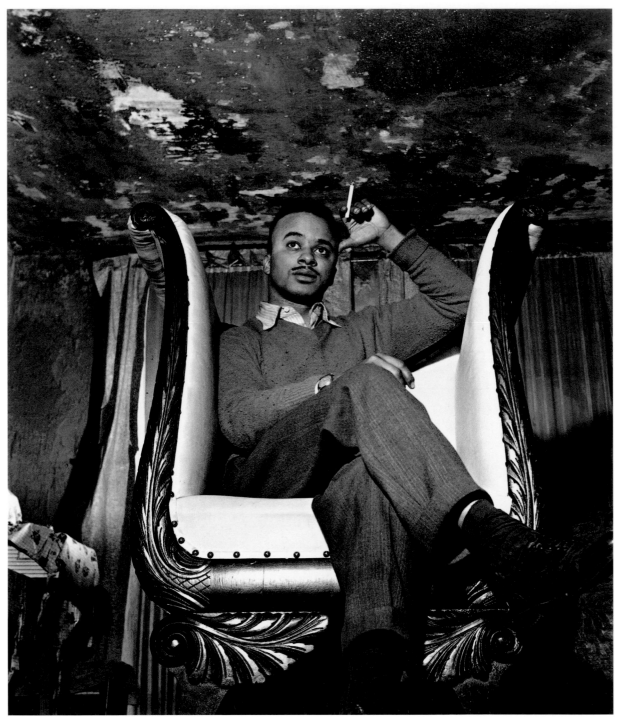

The painter Eldzier Cortor in his
basement apartment

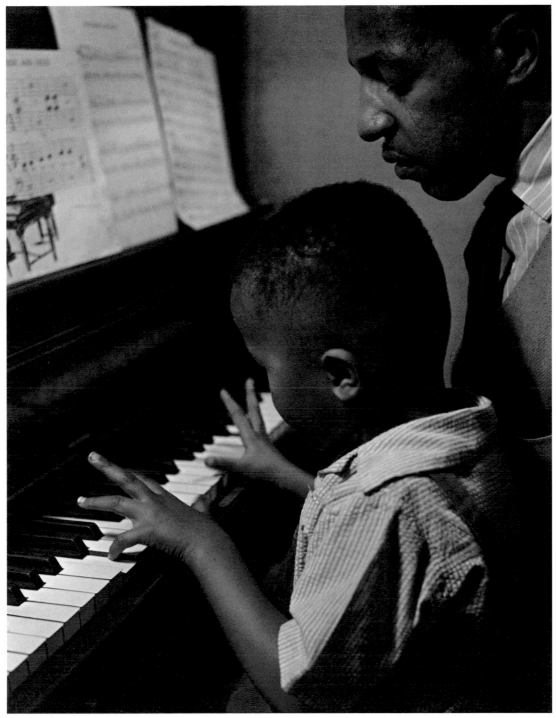

This boy's father traded paintings
for piano lessons.

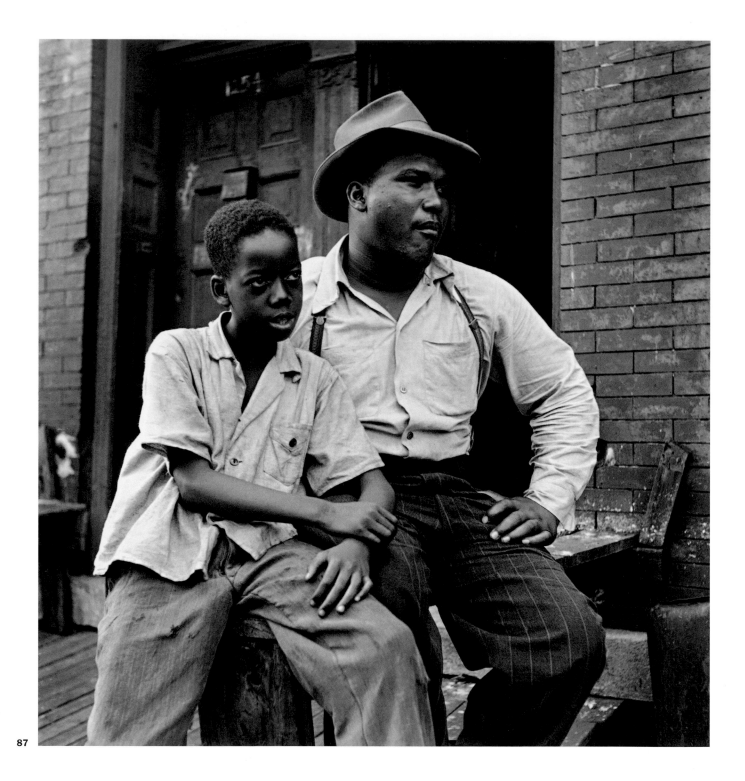

Father and son

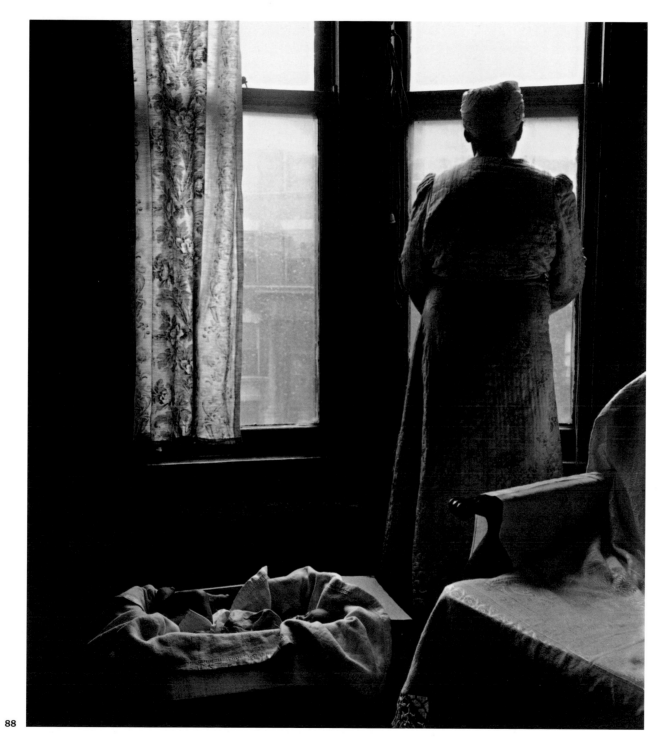

88

A deserted mother wondering
what to do with a newborn baby
she cannot support

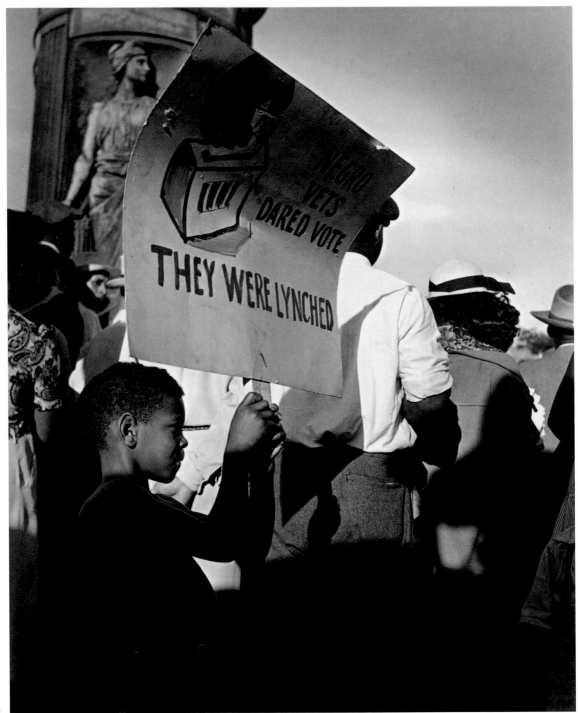

89

Anti-lynching demonstration

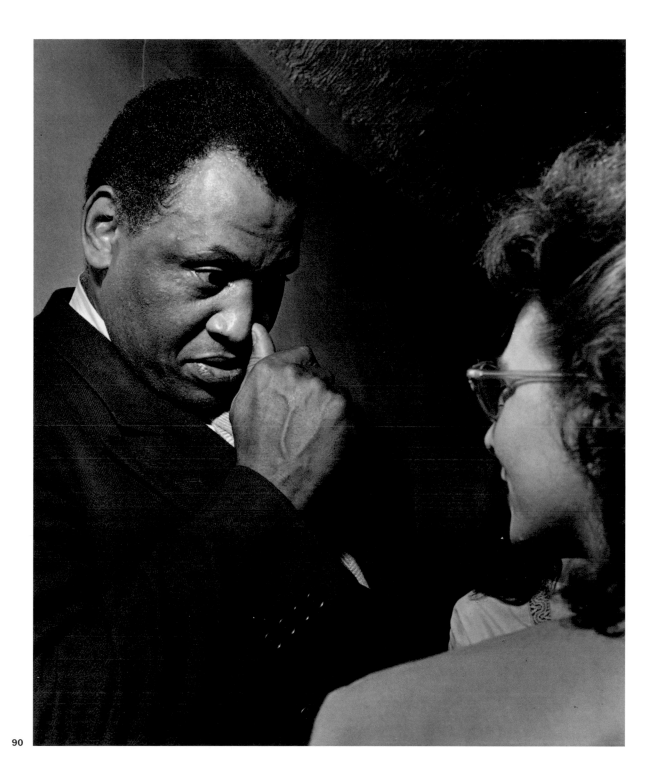

90

Paul Robeson

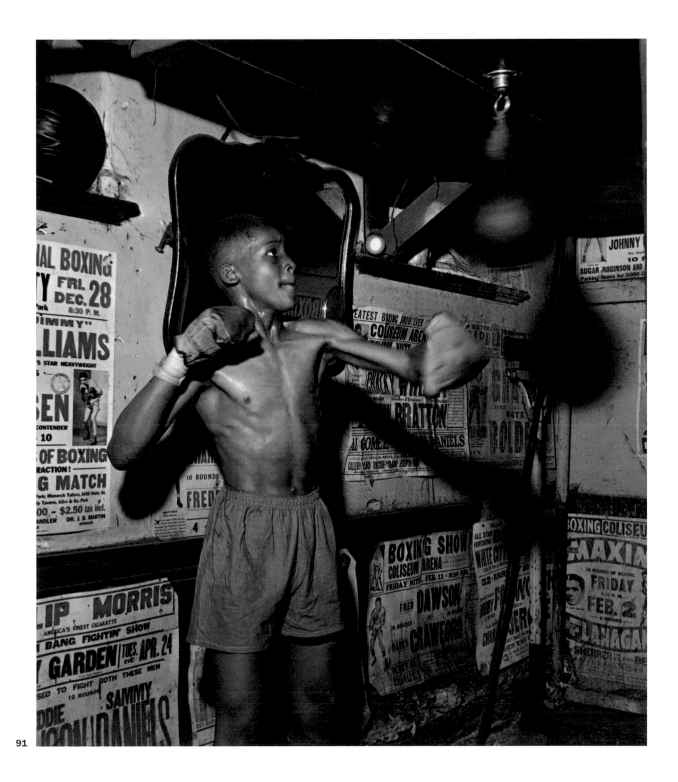

91

Eddie Nichols Gymnasium at 50th and
State was a popular gym for young boxers.
Joe Louis worked out there.

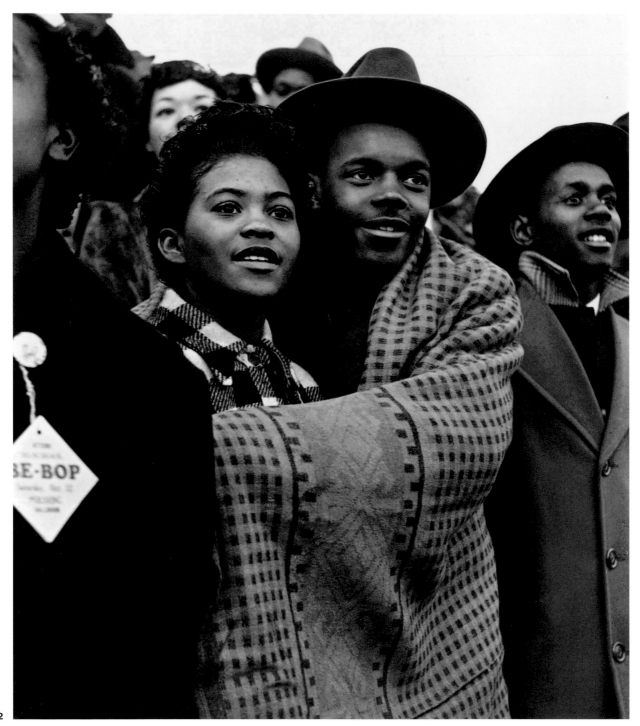

Watching Dunbar vs. Phillips high school
football game, 1946

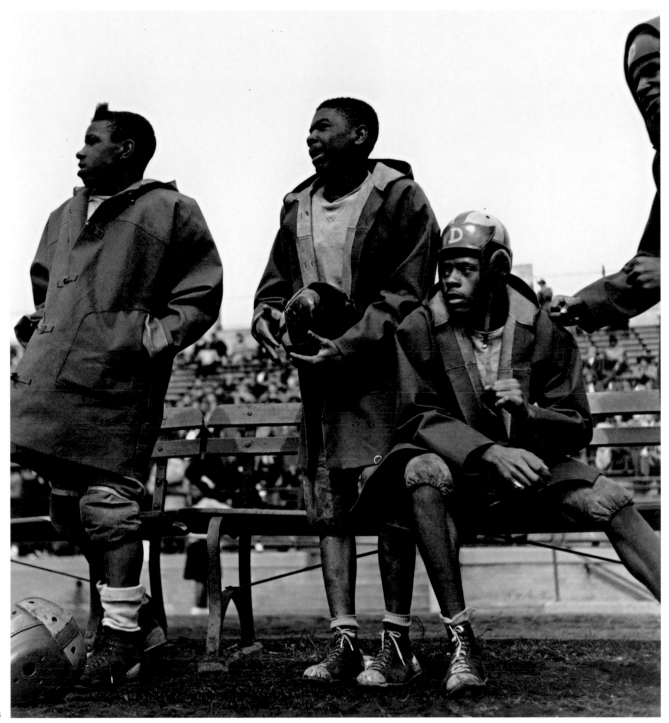

High school football players

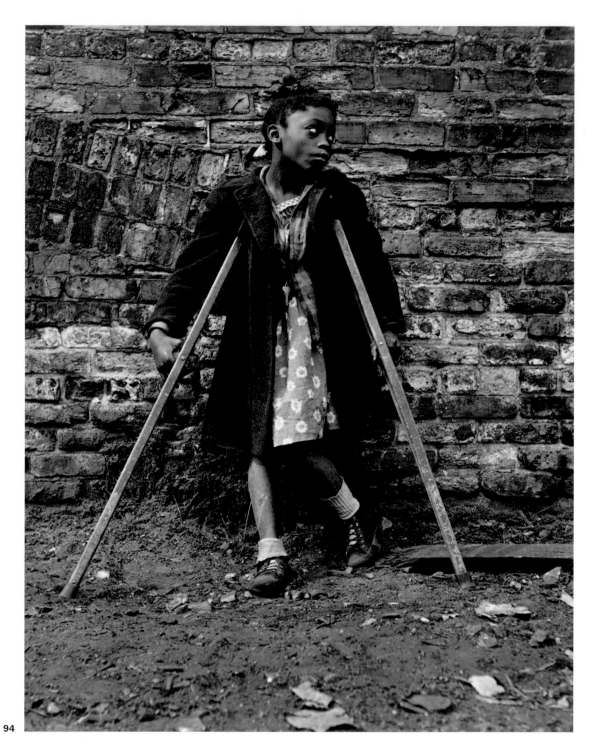

Latchkey girl

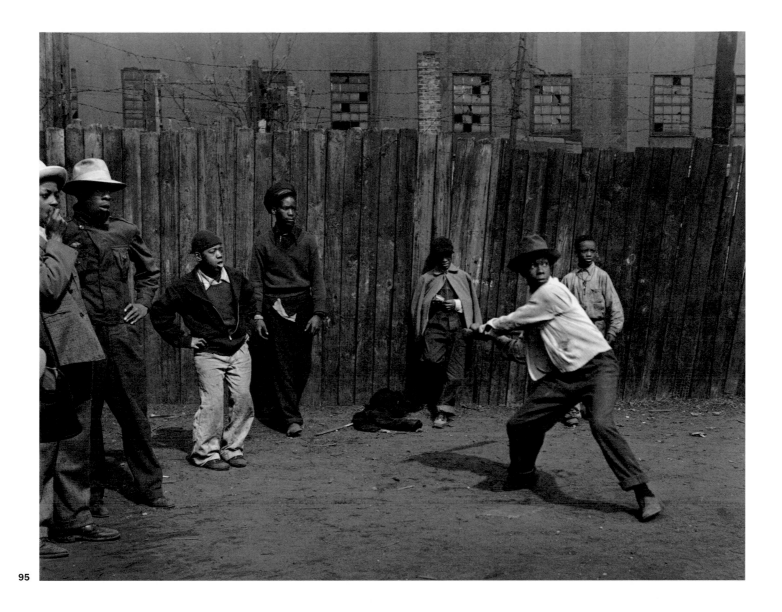

Sandlot baseball

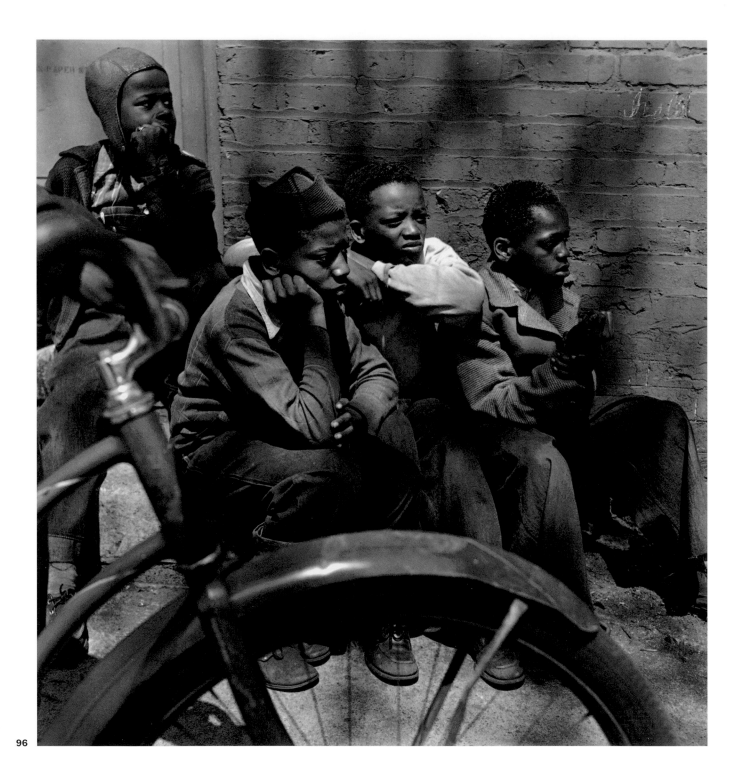

After school

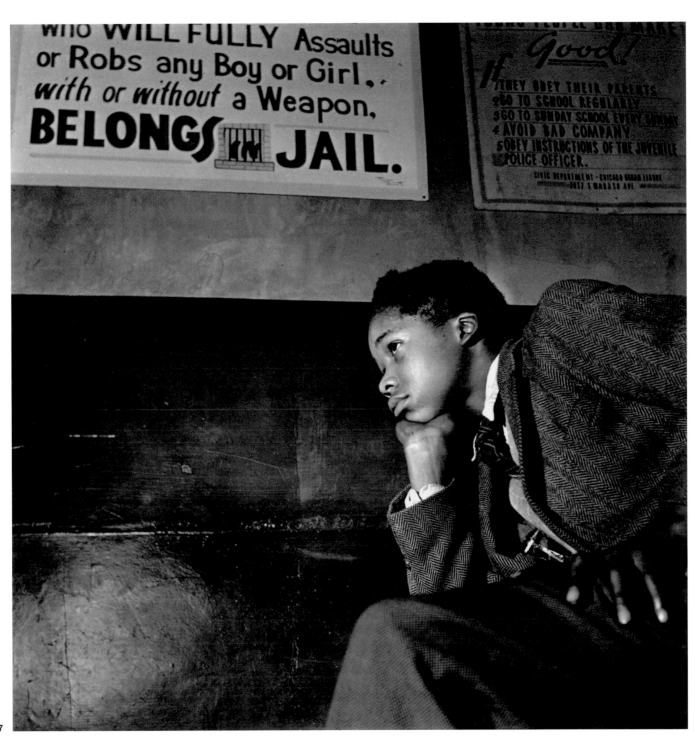

Kangaroo court for juveniles at the Wabash
Avenue police station presided over by
Silvester "Two Gun Pete" Washington

97

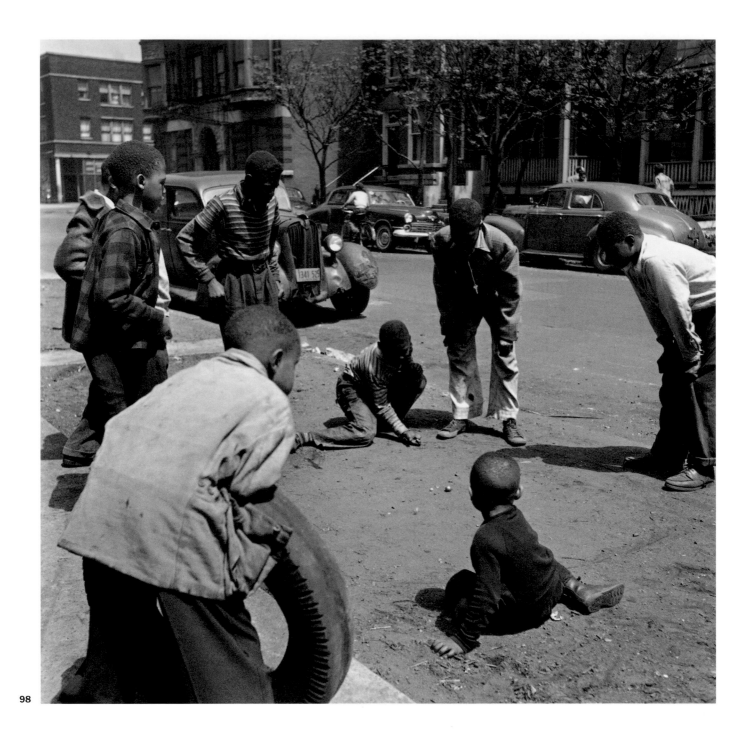

Playing marbles

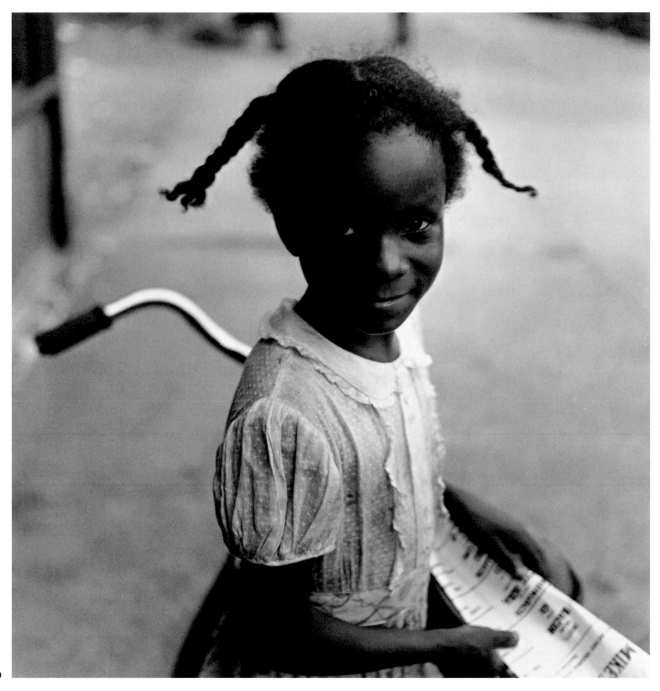

A girl with her bike

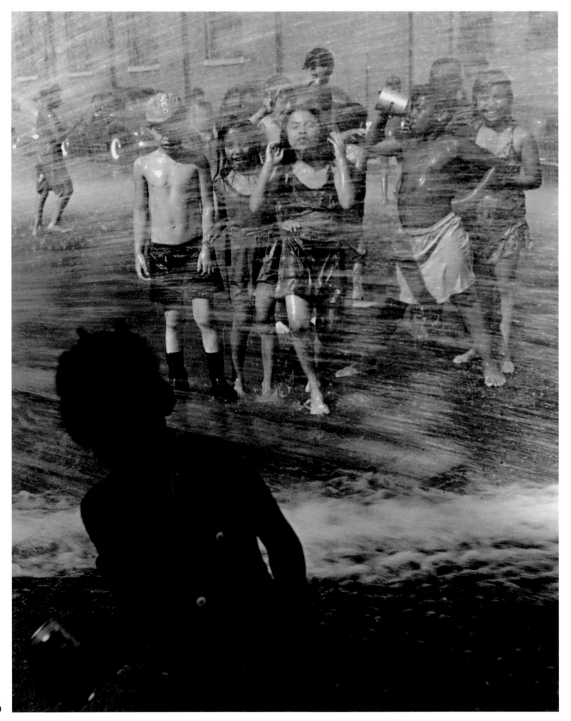

100

Heat wave, August 1947

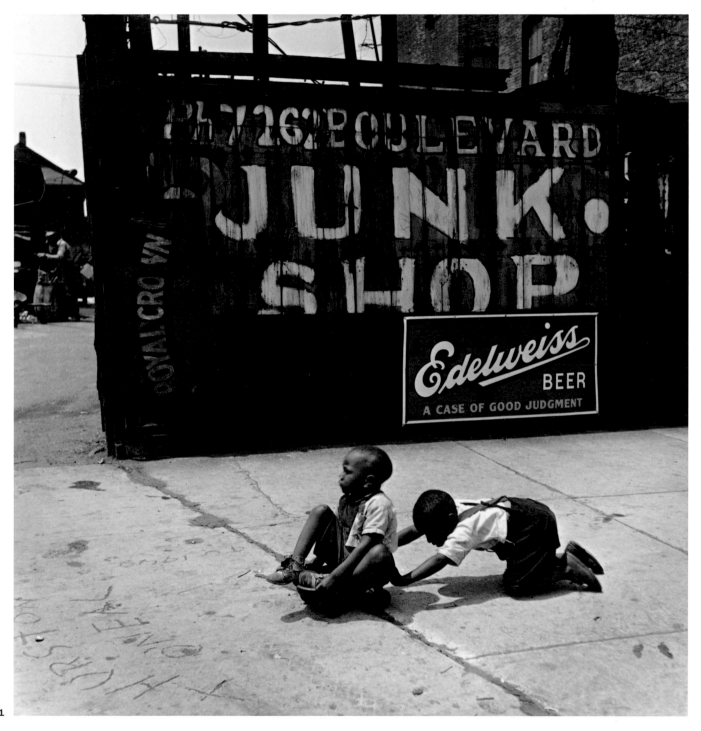

101

A makeshift pushcart

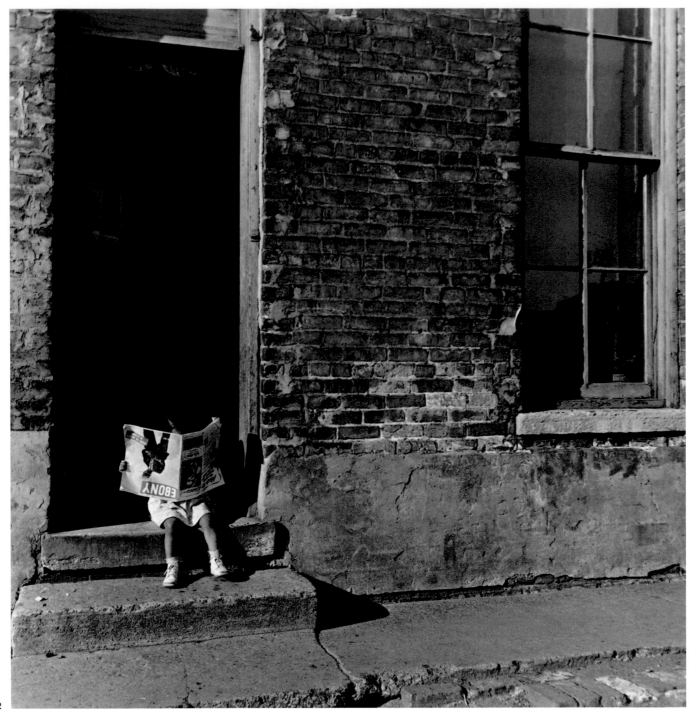

Girl "reading" *Ebony* magazine

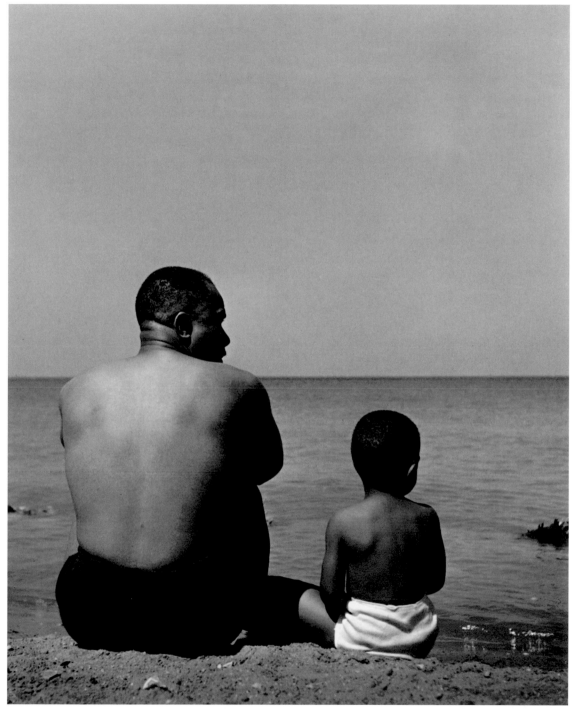

103

Father and son at Lake Michigan

ACKNOWLEDGMENTS

Many people and institutions, knowingly or unknowingly, have created this book and to all of them I am deeply grateful.

The title, *Chicago's South Side,* comes from a series of projects financed by the Work Projects Administration, in the early 1940s, that were directed by Horace R. Cayton and St. Clair Drake. Their report *Black Metropolis* was published by Harcourt, Brace and Company in 1945. Their findings and friendly support were most important to me.

When I became interested in this subject matter, Edward J. Steichen sponsored my application to the John Simon Guggenheim Foundation, and after it was granted, Henry Allen Moe, its president, continued to encourage me.

At this time Horace Cayton was director of the Parkway Community House in Chicago. He introduced me to his community and became my mentor and friend. Without his help, I could not have made these photographs.

Frazer Lane of the Urban League pointed me toward housing and juvenile problems. Several of his specific introductions are in this book. A fine man.

Ben Burns, editor of *Ebony* magazine, welcomed me during its first year of publication and gave me assignments that opened my eyes to the bigger world of the black community. Many of the photographs here resulted from his assignments. Thank you, Ben.

On some of these *Ebony* assignments I worked with Bob Lucas, a highly intelligent reporter. His fine sense of humor gave balance to my efforts to understand.

Scott Tyler, photographer for the *Chicago Defender* newspaper, was filled with youthful exuberance, and his observations and introductions further expanded my awareness of this new world. He loved ice cream.

Wilbur Perkins was also young and eager to help. He lived on the edge and survived in a culture that had no boundaries. He introduced me to some of that world. Wilbur was a good friend and a good father to his young daughter.

Eldzier Cortor is an exceptional artist whose paintings are of another era, yet we could talk about the day's realities and tomorrow's dreams. I have the greatest respect for him and for his wife and children.

If it were not for Ken Light, director of photography at the Graduate School of Journalism, University of California at Berkeley, these photographs would not have seen the light of day. He found them in my files and made possible their exhibition at the school. When it was decided to put them in a book, he advised and prodded me to get my ideas on paper and to meet the book's deadlines.

It was Orville Schell, dean of the Graduate School of Journalism, who made this publication possible.

His enthusiasm plus a generous grant from Susie Tompkins Buell prompted him and Susie to make this book the first of four that the school will be publishing. To each of them, I am most grateful.

Jim Clark, the talented and enthusiastic director of the University of California Press, is the one who made key decisions on what this book finally looks like. Jim, I want you to know my appreciation.

Sue Heinemann, as my editor, kept me in the right direction, and Nola Burger, as designer, with her keen sense of taste and design, has added much to this book. You both have made me look good. Thank you.

My earlier exhibition at the Graduate School of Journalism exhibition was curated by Kerry Tremain. He has a gentle way of getting the job done. His sensitivities and professionalism were important in the choice and the relationships of the photographs presented here. Thanks, Kerry.

The subsequent exhibition at the African American Museum and Library in Oakland was directed by its senior curator, Robert L. Haynes. His treatment of the installation and the viewers' positive acceptance exceeded my expectations.

If you like the prints in this book, it is due to the care and sensitivities of Eric Gran, who made them. His talents and good humor made this joint effort a lot of fun. It wasn't easy working with me; this alone makes him an exceptional man.

Robert B. Stepto's perceptive essay sets the stage for the world I worked so hard to capture in my photographs. His historical awareness gives dignity to those who struggled so hard to survive and achieve in those years. I feel complimented to be in his company.

Finally, it was beyond my greatest hopes that Gordon Parks would agree to write an essay for this book. He knew and experienced South Side's nerve ends and heartbeats. He speaks with authority, anger, and love. Only a fellow photographer can understand what his words mean to me. His graciousness is matched only by his outstanding talents and brilliance in so many fields. Gordon, thank you.

Dan Dixon brought order and structure to my confused early essay attempts. I had tried to articulate my hopes, emotions, and imaginings and had made a mess I could not untie. Thanks, Dan, for making me look professional.

And now to you, Joan. You put up with my dreams and struggles while I was taking these photographs fifty years ago. Your continuing patience and support, then and now, is beyond compare, and your love and constructive criticism have made everything possible.